SCRANTON

A BRIEF HISTORY OF
SCRANTON
PENNSYLVANIA
CHERYL A. KASHUBA

Charleston London

THE
History
PRESS

Published by The History Press
Charleston, SC 29403
www.historypress.net

Copyright © 2009 by Cheryl A. Kashuba
All rights reserved

First published 2009
Second printing 2012
Third printing 2013

Manufactured in the United States

ISBN 978.1.59629.810.1

Library of Congress Cataloging-in-Publication Data

Kashuba, Cheryl A.
A brief history of Scranton, Pennsylvania / Cheryl A. Kashuba.
p. cm.
Includes index.
ISBN 978-1-59629-810-1
1. Scranton (Pa.)--History. 2. Scranton (Pa.)--Social life and customs. 3. Scranton
(Pa.)--Economic conditions. 4. Scranton (Pa.)--Buildings, structures, etc. I. Title.
F159.S4K36 2009
974.8'37--dc22
2009041651

CONTENTS

CONTENTS

PREFACE

S cranton's history is filled with interesting and unique stories, each of which contributes a thread to the vast, rich tapestry that is its past. When I began to work seriously on the city's history back in 2004, I quickly recognized the spirit of ingenuity and the sense of purpose that transformed a wilderness into first a frontier town and then a cosmopolitan industrial city. That transformation happened within a matter of decades as people came here to forge new ground and to make their fortunes or simply to find work that would sustain their families. They flooded into the Lackawanna Valley by the tens of thousands, coming from all parts of the world and bringing with them customs and culture that would become part and parcel of a vibrant urban life.

In the course of its development, Scranton contributed significant innovations, such as the use of anthracite coal as a fuel source and the first all-electric trolley as a means of modern transportation. It built a fine school system, endowed an impressive library and established hospitals, churches and a host of civic and charitable organizations. Its theatre scene became nationally known and its cosmopolitan atmosphere celebrated.

Taken together, these threads form a picture of life that is distinctly American yet surprisingly unique. To collect this history and put it down on paper is indeed a daunting task. The scope is simply too large to examine, in close detail, every facet of a history that includes so much. This book humbly bows to the rich and complex history of our city and, in an attempt to do that history justice, looks at its dominant threads and examines in some

detail individual accomplishments that stand out as representatives. For readers who want a more detailed account of a specific topic than the ones I offer here, I have included a series of contextual endnotes that name sources where that information can be found. I think you will agree that the history contained within these pages is a rich, varied and endlessly fascinating one.

ACKNOWLEDGEMENTS

My work is possible because of a community of caring and dedicated people, each of whom has my deep gratitude.

First, Dr. Darlene Miller-Lanning, director of the Hope Horn Gallery at the University of Scranton, whose 2004 invitation to work on a book and show about the history of Scranton launched my career in local history.

Mary Ann Moran Savakinus, director of the Lackawanna Historical Society, whose open doors make my work possible, and her dedicated board of directors, staff and volunteers, who do what they do out of love for our community's history. I especially wish to thank Mary Ann Gavern, the late Marion Yevics, Ann Marie O'Hara, "Uncle Bob" Booth and the late Maurice MacNamara.

Larry Beaupre, managing editor of the *Scranton Times-Tribune*, for his decision to add a local history column to the paper's Sunday edition and for permission to use photographs from the newspaper's collection.

Brian Fulton, library manager at the *Scranton Times-Tribune*, whose behind-the-scenes support is unmatchable.

The community of people who keep our history, including Ella Rayburn, curator at the Lackawanna Historical Society; Chester Kulesa and Richard Stanislaus at the Anthracite Heritage Museum and Lackawanna Iron Furnaces; Natalie Gelb Solfanelli, executive director of the Lackawanna Heritage Valley Authority, and her staff, especially Colleen Carter, Dan Perry and Sarah Pacini; Sherman Wooden, Cindy Wooden and Kim Glomboski of the Center for Anti-Slavery Studies; Jack Finnerty, director of the Albright

Memorial Library; and Laurie Cadden, community development director of the Scranton Cultural Center.

To the individuals whose insights have helped me to better understand local history, including Jack Hiddlestone, Norm Brauer, the late Mark Boock, Jerry Loeffler, Tom Costello, Joe Ricardo, Joe Gilroy, Jo Ann Bogdanovicz, Sandy Connell, Norma Reese at Forest Hill Cemetery, Ed Osman, Fran Tartella, Bill Conlogue and Bridget Conlogue and especially the Azzarelli family, Dominick, Margo and Marnie, for sharing research and offering undying love and support.

To members of the acting troupe Past Players, who on more than one occasion helped me bring local history to life.

To my Wednesday noon group at Anthology New and Used Books, for giving me a place to talk local history, and to Andrea Talarico for providing such a fabulous venue.

To Hannah Cassilly at The History Press, for insight and guidance from the proposal through the book's completion.

To my family, who have offered support of a very different and much-needed kind. To my son Matt, for sustaining me with meals through the process of putting this book together. To my aunt, Helen, who saw to it that my childhood summers included trips to Nay Aug Park and the Everhart Museum. To my parents, Mike and Gerry, without whom I simply could not have completed this work.

A special thanks to all those who read my local history column each week—for the kind words and continuous support.

A special and heartfelt thanks to the late Alan Sweeney, my friend and mentor, who was himself a walking local history book. I miss you, Alan, but your presence is with me always.

And finally, to my grandparents, the late Agnes and Mickey Kashuba, whose stories nurtured and shaped me as I grew, and whom I can feel smiling down on me every time I write a word about local history.

INTRODUCTION

The Lackawanna Historical Society was established in 1886 as the Lackawanna Institute of History and Science to preserve the history of Pennsylvania's youngest county. The society took an early lead in collecting works of art, objects relating to local history and, perhaps most importantly, a collection of published books, unpublished manuscripts, maps, photographs and documents that have come to make up the society's archives.

Because of the organization's active role in preserving the heritage of the region, the Lackawanna County government designated the Lackawanna Historical Society as the official county historical society in 1965. Today, the society accomplishes its mission of keeping vital the history of Lackawanna County and encouraging a wider appreciation of local history through exhibits, programs and publications. The Lackawanna Historical Society is pleased to be the county's keeper of history, and I, personally, am grateful to work as the director of the organization because every day I have the opportunity to learn more about our fascinating history and the amazing things that have been accomplished by our forefathers. It is through their human stories that we can truly relate to our local heritage.

Simply review the major elements of our local heritage. The Lackawanna Valley embodies the American experience. Sparsely settled in 1820, the narrow isolated valley in northeastern Pennsylvania grew within several short years to become one of the great industrial districts on the continent. The story of the Lackawanna Valley is unique and yet distinctly American. It mirrors the rise of the United States to world industrial preeminence during the nineteenth and twentieth centuries.

Before becoming an industrial center, Scranton was home to Native Americans. The name "Lackawanna" is derived from a Native American word that means "fork in a stream," which describes the path of the Lackawanna River. Scranton was originally known as Capouse Meadows, which was named after the chief of the Monsey Tribe, who settled here in the mid-1700s. Messages were once posted on an old apple tree near Weston Field to keep everyone informed. The first permanent settlers to the Lackawanna Valley migrated here from New England. They were of English descent and came to take advantage of the lush agricultural and timbering resources. Their land acquisitions came through the colonial Connecticut claims of land granted in the original charter of the king of England in the seventeenth century, clashing with new arrivals under the colonial government of Pennsylvania. Colonial settlement was hampered at first due to these conflicting claims on the land by both Pennsylvania and Connecticut.

The Tripp family were some of the first white settlers in the region, and Isaac Tripp built his home in the Providence section in 1771. The Slocum family arrived shortly after this and established a small farm in an area of downtown Scranton and South Side, which would become a small village known as Slocum Hollow. These early settlers came mainly from New England and worked the land as farmers, but as more and more settlers arrived in the area, it was soon determined that the land of the Lackawanna Valley offered something more—something that would not only change the lives of the local residents, but that would also contribute to the industrialization of the entire country in a significant way.

George and Selden Scranton arrived in 1838 and purchased the old Slocum property to develop an iron manufacturing plant. The plant became known as the Lackawanna Iron & Coal Company, and with its success, the region thrived. Immigrants flocked to the area to work not only in the iron mill, but also for the railroads and the anthracite coal companies that were established here to take advantage of the natural resources. In 1847, the Lackawanna Iron & Coal Company became the first American company to mass-produce iron rails, sparking a boom in the local railroading industry. Anthracite coal, indigenous to this area, fueled railroads and heated homes. From the 1870s through the 1920s, northeastern Pennsylvania supplied over 85 percent of the world's anthracite coal. Anthracite was king, and Scranton was the Anthracite Capital of the World.

These industries spawned other industrial manufacturing and drew European immigrants in large numbers. These included, among others, the

textile industries that employed immigrant women and girls. By the mid-1890s some 140,000 miners were employed in the Pennsylvania anthracite mines, and it has been further estimated that during the second half of the nineteenth century, the number of different individuals who worked at some time in the anthracite fields could be close to 1 million! Just imagine how many people around the world today can trace their lineage to the Lackawanna Valley. These flourishing industries also contributed directly to our national economy; labor unrest and child labor issues combined with industrial success to make Scranton a microcosm of the later industrial era.

But our story reaches beyond industry itself, as the city's social history reveals. Charitable organizations such as the Home of the Friendless stepped in to alleviate societal ills. Thomas Foster started the International Correspondence School to teach a mining course through the mail and ended up with a unique and extensive distance learning program. Churches, schools, hospitals and a library formed the foundation of a thriving culture. Shops, restaurants and small businesses of every kind, as well as theatre, sports, the first viable all-electric trolley system in the country and a host of other activities, made Scranton a cosmopolitan city.

The prosperity of the industrial boom, from 1870 to 1930, blessed us with tremendous architecture throughout the city. One example, Lackawanna Avenue, which has always been a thriving commercial avenue in the city, was once the home to the city's major shopping venues and hotels. Today it stands to remind us of just how prosperous the city once was in its continuing growth and change.

Mary Ann Moran Savakinus
Director, Lackawanna Historical Society
August 2009

PIONEER DAYS

NATIVE PEOPLE

A small village nestled itself along the rich banks of the Lackawanna River. Home to a branch of the Leni-Lenape (called the Delaware by white settlers), known as the Monsey or Munsee, the group had occupied this spot in the wilderness since at least 1700. The people lived in wigwam-style dwellings. From flint stone they fashioned agricultural implements, and they also planted maize.[1] Within the clearing that formed their village stood a number of old apple trees. The first white people to come into the region found one venerable old tree thirteen and a half feet in circumference. This tree appears on old maps of the area. The river they called *Lee-haw-hanna*[2] teemed with perch, pike and shad. Muskrat, beaver and ducks thrived. Deer, elk, moose, rabbits and pheasants inhabited the woods around the village. The people made fishing hooks of bone, wove nets from the inner bark of trees and shaped stone into elegant arrowheads and spears. From the clay of the earth they made pipes and bowls. They traveled the river by canoe, hunting and fishing as far upstream as its headwaters. They lived their lives in a manner honored by time, and they buried their dead along the Lackawanna about a half-mile above their village.[3]

White settlers would call this village Capoose (later Capouse) after the chief of the native people. The nearest native neighbors occupied a village

called Asserughney to the south, located at the spot where the Lackawanna and Susquehanna Rivers meet. But theirs was not a placid life. Because they did not record their history, dates can be difficult to pinpoint. The Iroquois fought them often over land, and eventually they were forced to submit to the rule of the Iroquois.[4] The Leni-Lenape were caught up in a struggle between the French and English as each fought to claim land for themselves. The Wyoming Valley to the south had been explored earlier, with some colonization. But the entire area from Wyoming Valley up into the Lackawanna Valley was a hotbed of trouble for a number of years. Part of the problem lay with conflicting land grants. In 1662, King Charles II granted the lands of the Wyoming Valley to the colony of Connecticut. The same king granted land to William Penn in 1681, but the land grants overlapped, and so Providence Township was in dispute. The New England settlers, called Yankees, and the Pennsylvania colonists, known as Pennymites (or Pennamites), both claimed the right to settle this land.[5]

PROVIDENCE AND HYDE PARK

At this time, land companies formed as a common means of buying land for settlement. The Susquehanna Company formed in the colony of Connecticut and, on July 11, 1754, for "the sum of two thousand pounds[6] of current money of the province of New York," bought an expanse of land in the Wyoming and Lackawanna Valleys. For many years, the conflicts involving the English, French and native peoples deterred settlers—both Pennsylvanians and New Englanders—from venturing farther into this wilderness. Eventually, some began to brave what was a seriously dangerous area. The Lackawanna Valley was explored in 1770, and the area between the two Indian villages of Capoose and Asserughney was laid out into two townships: Pittston and Providence. Soon, in 1786, Luzerne County would be organized and these townships would be a part of it. Originally surveyed at five miles square, Providence Township took in the areas that would become Providence village, Tripps Flats, Hyde Park and Slocum Hollow—and that would, even later, become the city of Scranton. In 1771,

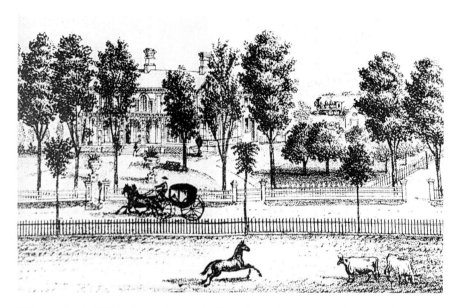

This drawing by Phillips Butler depicts the Tripp family homestead as it appeared about 1859, a time of transition. *Courtesy* Scranton Times-Tribune.

Timothy Keyes and Solomon Hocksey, two young men from Connecticut, "struck the first blow into the woods" of Providence Township. "With a gun and ax they penetrated the willowed glen now known as Taylorsville [later, Taylor], where they built their cabin by the side of the brook named from Mr. Keyes [Keyser Creek]. One vast park, filled with deer, stood between this creek and Capoose, marked by a single foot-path."

That same year, Isaac Tripp, a man of thirty-five and an original proprietor of the Susquehanna Company, chose a spot on a hill overlooking the village of Capoose. There he built a cabin among the pines. Tripp was new to this spot, but he was not new to the region. He had left his native Providence, Rhode Island, in 1769 and settled in Wilkes-Barre, only to be driven out by Pennsylvanians who denied his claim to what they considered their land. The members of the Susquehanna Company appointed Tripp and several others to a committee whose purpose it was "to exercise a general superintendence over the affairs of the forty settlers" who made up the company and who had come to the area around Capoose to settle.[7] As such, Tripp was involved in attempts to reclaim land in the Wyoming Valley. When the American Revolution broke out, the English often stirred the native people into attacks on the settlers.[8] As an active and forceful member of the Susquehanna

Company, Tripp attracted the attention of the British. They wanted him dead, and they got their wish. Isaac Tripp was shot and killed by native people, at the urging of the British, near the fort at Wilkes-Barre in 1779.

But the trouble was not over for this family. Horace Hollister, one of the area's original historians, quotes a passage taken from a small volume compiled by the Abington Baptist Association, in which the claim is made that Isaac Tripp—the grandson of the first Isaac Tripp, the one who had been shot and killed—was taken captive by members of the native population soon after the Wyoming Massacre, when he was eighteen years old. According to the account, he and some others were marched to Canada:

> *On the way he experienced the most excruciating sufferings from the gnawing of hunger and cruel treatment of the savages, who bound his hands behind him and compelled him to run the gauntlet. At Niagara, he met his cousin, Miss Frances Slocum, who was also a captive from the Wyoming Valley. They planned their escape, but their intentions being discovered by their captors, they were separated, never more to meet on earth, and young Tripp was sold to the English and compelled to enter their service, in which he reluctantly continued until the close of the revolutionary war.*

The ongoing troubles posed a real threat to these determined settlers, and many fled the area and returned on more than one occasion. Hollister writes: "People in our day, familiar only with the smooth current of rural life, can hardly estimate the exposure and insecurity of that period." Men working their fields kept their knives at hand. In 1772, they voted that each and every settler should have a flintlock and ammunition.[9]

When the American Revolution broke out, all factions aligned themselves in accordance with that war. The situation reached a crisis point in July 1778. A combined force of British and native people attacked the settlement at Wyoming, massacring hundreds.[10] On their way north, this force passed through the Lackawanna Valley, burning crops and cabins as they went. The party captured both Keyes and Hocksey at their settlement and Isaac Tripp (son of the man who had been shot) near his cabin.[11] According to Hollister's account, the group of native people hurried their captives to an area above Leggett's Gap. "Resting one night, they rose the next morning, traveled about two miles, when they stopped at a little stream of water." Some of the group took Keyes and Hocksey "some distance from the path" and left one to guard Isaac Tripp. "Presently," Hollister writes, "the death whoop was heard, and the Indians returned, brandishing bloody tomahawks and

exhibiting the scalps of their victims. Tripp's hat was taken from his head and his scalp examined twice." For whatever reason, they told him not to worry because he would not be hurt. They "painted his face with war-paint as a protective measure against any warriors chancing to meet him, and sent him back to his home, at Capoose." The next year, a party of native people passing through shot him as he worked in his field.[12]

The end to this constant upheaval finally came in June 1779 when General George Washington, commander of the American army, sent General John Sullivan on a campaign into the region. Sullivan and 2,500 men moved up the Susquehanna River Valley and into the Lackawanna Valley, heading north to New York. In a move to stop the native people who were assisting the British, they burned their villages and crops, crippling them. The local tribes were driven from the area.[13]

<center>——•——</center>

DAILY PIONEER LIFE

In the midst of these threats, the people who settled Providence Township toiled daily to make lives for themselves. The Tripps, Andrew Hickman, Frederick Curtis and other families tended the soil and planted crops. They grew wheat, some of which they carried a distance of nearly seventy miles to Easton. Here they might sell it for seventy or eighty cents per bushel or trade it for large iron kettles in which to boil maple sugar. The journey took one week by wagon. Farmers would hire out the kettles to neighbors with maple woods. The fee was one pound of maple sugar per year for each gallon the kettle held. Hollister writes: "The maple sugar, run into cakes of every conceivable variety and size, was worth *five cents* per pound, and was for a long time the only kind used in the settlement."

The work of clearing the land laid waste to the old apple trees left by the native peoples. For reasons known only to them, the settlers left the largest one standing, and it appears, clearly labeled, on the old maps of the neighborhood. One of the trees, when felled, was found to have 150 concentric circles, dating it "back to a time long before the reports of the trapper or the story of the Indians came out of the valley to the whites."

Upstream from the old village of Capouse, in the area that would become Providence Square, a new village grew. Enoch Holmes was its first resident.[14] Everyone called it Razorville. Elisha S. Potter and Michael McKeal established a country store at what would become the southwest corner of Market and Main Streets. Customers could buy on credit. In the absence of newspapers or pamphlets, the citizens of Providence village were notified of meetings by a handwritten sign posted to the old Indian apple tree. This arrangement was a legal one, and each township within the Connecticut settlement had its own tree designated for posting notices. These notices "made a meeting *legally warned*."

The settlers found ways to incorporate a social life into their work. People often met for a logging bee, for example. At the bee, they rolled logs in heaps and burned them. These were old-growth logs and would have made fine timber. But before the advent of railroads, there was no way to get them to market, and so the villagers simply burned them to get them out of the way. Farmers raised sheep for wool. Young girls would gather in the neighborhood, usually under the shade of a tree, with their wool or their flax, spinning wheels in hand, and "knot after knot of yarn came from their nimble hands." The yarn or thread was then woven into garments, sheets or other items for household use. This gathering served as a social event, and afterward, the young women would be joined by other members of the community for a supper that might consist of rye bread, pumpkin pies, Johnny cakes, doughnuts, fresh milk and whiskey. No activity took place without whiskey. It was cheap and readily available. What's more, it was a good way to use the grain they grew. Those among the settlers who held to the New Englanders' Puritanical sense of morality took issue with the level of drinking. At a meeting held in Wilkes-Barre on February 16, 1773, a committee made up of William Stewart, Isaac Tripp, Esq., and others drew up "a plan in order to suppress vise and immorality that abounds so much amongst us." But the beverage was "used from the cradle to the grave. Children put to sleep by eating bread soaked in whisky and maple sirup [*sic*], gave no trouble to mother or nurse."

Meanwhile, just up the hill to the southwest of Providence village, the Dolph family began to settle. In 1795, Aaron Dolph built a log house. His brother Jonathan cut down trees and made a farm, while Moses Dolph cleared yet another site. Jonathan also established the first tavern in the community. It would be some time before a road opened up between Providence village and Hyde Park. That road would become Main Avenue. In 1794, William Bishop settled on the east side of Hyde Park. An Englishman, Elder Bishop

James Tripp and his son William appear in a covered wagon about 1908. *Courtesy Lackawanna Historical Society.*

was a Baptist preacher who set up a church. "It was a rude, paintless affair," Hollister writes. "No bell, steeple, pulpit, nor pews, marked it as a house of worship; four plain sides, chinked with wood held by adhesive mud, formed a room where the backwoodsmen gathered in a spirit of real piety." The first school was not built in Providence village until 1818. "Previous to this," Hollister writes, "schools were kept in private houses, and sometimes under the shade of a tree in summer, and some, if taught at all, were taught to read, write, and cipher by the fireside at home."[15] The villagers built a church in 1834, but in July of that year, a tornado devastated the town, and the villagers did not attempt to rebuild the broken church.[16]

The only medical care came in the person of Dr. Joseph Sprague, a native of Hartford, Connecticut, who bought considerable land and settled here in 1771 as the first physician. He lived near the river and enjoyed "fishing, hunting, and farming until, with the other Yankee settlers, he was driven from the valley, in 1784, by the Pennymites," according to Hollister. He died in Connecticut the same year. His widow returned to the region in 1785 and settled in Wilkes-Barre. She was known locally as Granny Sprague. "Although of great age, as late as 1810 her obstetrical practice surpassed that

of any physician in this portion of Pennsylvania...no matter how distant the journey, how long or fatiguing the detention, this sturdy, faithful woman invariably charged *one dollar* for services rendered." Sprague made a profit by selling his land in lots, for the community did indeed grow. It grew slowly, but it did grow. Dr. Silas B. Robinson settled in the township in 1823 and practiced for nearly forty years. He died suddenly in 1860.

"Nothing tended to give a vigorous direction to Providence toward a village," Hollister contends, "more than the Philadelphia and great Bend Turnpike." Also known as the Drinker Turnpike, it passed through the village. Three times per week, a stagecoach came through, carrying passengers and mail. It took two days to make the trip to Philadelphia. The road, chartered in 1819, was completed in 1826. Other roads included the Connecticut road, long traversed by the emigrant, which passed over the rough summit of the mountain, cut by Roaring Brook. The Luzerne and Wayne County turnpike intersected the Drinker turnpike at Providence.

SLOCUM HOLLOW

In May 1788, Philip Abbott walked along a ledge of rocks above a brook called *Nay Aug* (or Roaring Brook). As he walked, Abbott marked the area of land where he would settle. A native of Windham County, Connecticut, Abbott had moved into the Wyoming Valley with his brother, James, prior to the Revolutionary War. In 1777, he sold that property to James and explored the region to the north, the Lackawanna Valley. By 1788, Philip Abbott was ready to settle. Using the tools he had carried with him, Abbott cleared the land, felling trees for his new home. It was a simple, one-room cabin, covered with a roof of tree boughs and heated by a fireplace.

Abbott had come into the region to explore potential sources of water power. At this time, this area along the Nay Aug was part of Providence Township. The corn and rye raised on farms at Tripps Flats, Hyde Park and other parts of the local region had to be carried twenty miles to a mill in the Wyoming Valley or hand-cracked with a mortar and pestle and eaten in this coarse state. The necessity of a mill in this community was obvious

to Abbott, and the running waters of the Nay Aug were a ready source of power. With his own hands, Abbott worked a suitable stone from the granite of a ledge. This would serve as the millstone. From the hide of an animal, he cut a length to serve as a belt, which he wrapped on the drum of the water wheel and over the iron spindle. When the water passed through the wheel, its power would move the belt, which, in turn, would move the grinding stone. The ground meal would pass through a sieve fashioned from deer skin, and in this way the finer flour would be separated from the coarser bran. To house the works, Abbott erected a simple wooden structure. This mill was so primitive that it could only crack the corn for *samp*, a course meal that was common in the valley at the time.

Primitive as it was, the mill provided a necessary service to the tiny settlements in this vast wilderness. Hollister writes of a trip to the mill from Leggett's Gap along the area that would later become Chinchilla:

> *The utter solitude of Leggett's Gap, interrupted only by the screech of the panther or the cry of the wolf, as they sprang along its sides with prodigious leaps, made even the trip to mill perilous in the cold season of the year.*
>
> *"Many a time," said [Ebenezer] Leach, "have I passed through the notch, with my little grist on my shoulder, holding in my hand a large club, which I kept swinging freely, to keep away the wolves growling at me; and to my faithful club, often bitten and broken when I reached home, have I apparently been indebted for my life."*[17]

Philip Abbott saw the need to improve and expand his mill. In 1788, the year he erected the mill, Abbott took on his brother James as partner. The following spring, in 1789, Ruben Taylor joined them. Taylor built a log house on the bank of the Nay Aug just below Abbott's cabin. His was the second dwelling place erected on these lonely shores. Glass was not to be had, so Taylor covered his windows—as was the custom among pioneer settlers—with the skins of animals shot in the surrounding forest. The men fashioned doors, beds, blankets and even clothes from animal skins. They cleared land and planted wheat and corn. They reaped their first crop in 1789. The following year, in the spring of 1790, a pair of New England Yankee brothers named John and Seth Howe bought the land and buildings from the Abbotts and Taylor.

The tiny settlement's water power and timber attracted the interest of Ebenezer and Benjamin Slocum. Their father, Ebenezer Sr., had settled the family in the Wyoming Valley prior to the Wyoming Massacre. In December

1778, near the fort at Wilkes-Barre, he was shot and scalped by the members of the native population. That same year, Slocum's young son, also named Ebenezer, was picked up by an Indian but was saved when his mother walked up to the man and said: "He can do you no good; see, he is lame." Instead, he took Frances, her daughter, age about five years, and hurried away to the mountains. She was never returned to her family but lived her life among the native people.

Brothers Ebenezer and Benjamin Slocum purchased from Howe his land and buildings in July 1798. They were single men when they arrived, but Benjamin Slocum married Miss Phoebe La France, while Ebenezer married a daughter of Dr. Joseph Davis. "The Slocums, young, strong, and ambitious, infused new elements into the settlement," Hollister says. They changed the name to Unionville, but it never stuck. People thereabouts just called it Slocum Hollow. They improved and enlarged the gristmill and added a distillery. Ebenezer brought in a partner, James Duwain, and the men added a sawmill to their holdings. The tiny pioneer settlement was growing: "A smith shop, built from the faultless logs, rose from the margin of the creek, and the sound of the anvil, carried far, blended joyfully with the song of the noisy water." The Slocums and company added two or three houses for the workmen they had hired to help with the growing business interests. Whiskey-making requires barrels, and so they built a cooper shop. By 1800, these establishments made up Slocum Hollow.

The Slocums operated a forge that used ore taken from the rock outcroppings that surrounded the Hollow. The ore was found in small pieces and broken into finer pieces, roasted in a charcoal fire and placed in cone-shaped furnaces constructed from stone. This heating process removed the slag from the iron. The cast iron was then heated again, rolled into balls and shaped by the trip hammer into various sizes and shapes. The iron produced here "was said to have been fibrous in texture, very stout, and little liable to rust." The forge operated continuously from 1800 to 1828, at which time the Slocums found it increasingly difficult to find a source of ore, and they ceased its operation.

Slocum Hollow remained a tiny pioneer settlement surrounded by wilderness interspersed occasionally by farms, but the Slocums were slowly changing the nature of the place. In 1805, Ebenezer Slocum built the first frame house on this side of the Lackawanna River. Slocum could not have known it at the time, but this dwelling would become a landmark that, in a few short decades, would be all that remained of the brothers' original settlement. The Red House, as it came to be known, became a gathering

place "where the fagot blazed and reflected back the light of smiling faces" and "the jest and the song went around and the old hall rang to the roof." Benjamin Slocum built the second frame house in the Hollow. "Facing the brook, it offered an admirable view of the forge and the sturdy artisans around it." In 1809, Elisha Hitchcock, a young millwright from New Hampshire, arrived, married Benjamin Slocum's daughter Ruth in 1811 and settled in to stay. As of 1810, Luzerne County had but two post offices—one in Wilkes-Barre and one in Kingston. A new one was established in 1811 in Slocum Hollow, with Benjamin Slocum as postmaster. Mail was carried from Wilkes-Barre once a week. Meanwhile, the Slocums added to their operations a second still in 1811. Even as civilization crept to the communities in the form of frame houses and post offices, "wild game thronged the thickets" surrounding these communities. Ebenezer Slocum retired from business in 1828, but the younger generation, Joseph and Samuel Slocum, continued this pioneer lifestyle when they took over the "farming and mill interests with the same spirit of earnestness distinguishing the elder Slocums."[18]

THE BIRTH OF INDUSTRY

Iron: The First Industry

William Henry guided his horse over a ridge and down into Slocum Hollow. The year was 1838, and Henry was about to take the first step that would transform this wilderness into one of the most important industrial cities in the country. Scranton has long been remembered for its coal industry. But before coal, and even before the railroads, came iron, the first pillar in the foundation of industrial life that would sustain thousands of workers for a century. A geologist, Henry had been the first person in the country to use the hot blast process in the manufacture of iron. Henry was aware of the abundant anthracite coal in the region, and he intended to establish an operation that would use anthracite to fire his iron furnaces. The plan was innovative, as anthracite was an uncommon fuel source. Henry sought financial backing from Edward Armstrong of the Hudson Valley, whose interest in the area's coal resources made it possible for Henry to proceed. He began to negotiate for 503 acres of land in Slocum Hollow. The owners—Zeno Albro, William Ricketson and William Merrifield—set the price at $15,000, a price to which William Henry would not agree. They lowered their price to $8,000, which Henry accepted on terms that he would present the owners with a $2,500 down payment from Armstrong. Mr. Armstrong drafted the check, but in a bizarre twist, he fell from his

horse and died just one day before the check arrived in Slocum Hollow. The executor of his estate immediately stopped payment. Left without money, Henry turned to his son-in-law, Selden T. Scranton, and Selden's brother, George W. Scranton. The men were proprietors of the Oxford Furnace in New Jersey and, in addition to financial backing, would bring knowledge of the iron industry into the partnership. Sanford Grant came in as a partner, as well.

Edward Merrifield, son of William Merrifield, one of the property owners, recalls an amusing anecdote about the purchase that would transform Slocum Hollow. It happened in 1840:

> *Well I do recollect the warm August day when George W. Scranton, Selden T. Scranton and Sanford Grant came to my father's place in Hyde Park to take the deed. George W. was the principle spokesman. Everything went smoothly until the married women objected to signing without the promise of a dress pattern. It was a Pennsylvania custom and these Jerseymen did not seem to understand the force of it. Parleying at once ceased, however, when George W. said it would be done even if at his own expense.*[19]

George Scranton's gesture in this deal turned out to be a sort of foretelling of things to come. In this partnership, it was his role in particular that was going to make the experiment work. And an experiment is exactly what it was. Two forges—one near Mauch Chunk (later Jim Thorpe) in 1838 and a second in Pottsville at about the same period—each succeeded in processing iron ore with anthracite coal. But neither lasted more than a few months, and the process was still very much experimental.[20] But the men went ahead and formed Scrantons, Grant & Company,[21] and the experiment went forward.

"September 11, 1840," writes Frederick Hitchcock, "is to this city what the Fourth of July is to our country—it is the birthday of Scranton." On that day, local resident Simon Ward struck the first pick into the ground and began the foundation for a blast furnace to be used for the smelting of iron and to be fueled by anthracite coal. William Henry supervised, along with master builder William W. Manness.[22] Work continued into 1841, and on October 9, the stack was filled with layers of coal, limestone and iron ore, and the men applied the air blast. But as the ore began to melt, the air passages became clogged with the mixture. They had to let the mixture cool into a solid mass and cut it out with drills, a tedious and labor-intensive process. This day had proven that the use of anthracite coal in the making of iron was still a risky business.

Shanty Hill developed to include small but neat homes for the workers and their families. *Courtesy Lackawanna Historical Society.*

In January 1842, in the midst of a seemingly endless run of failures, Selden Scranton set out on horseback for Danville to see if he could find someone who had some experience making iron with anthracite coal. He returned to Slocum Hollow on January 10 with John F. Davis, a Welshman who had had some experience in his native country. They tried again, with moderate success. On May 23, after some modifications, they lit the furnace again. This time, it went nonstop until September 25, at which point they were obliged to extinguish it because it burned too hot. But they had succeeded in making 374 tons of iron. The furnace was still not a sure thing, but it was—as this run had proven—ready to start turning out iron. The promise of work in a new industry had begun to attract Welsh, Irish, English and German workers. Quickly, the Hollow was transforming itself into an odd mixture of large industrial site and residential neighborhood. "I came here in 1840 with my father [who] had been hired to work at the blast furnaces," John

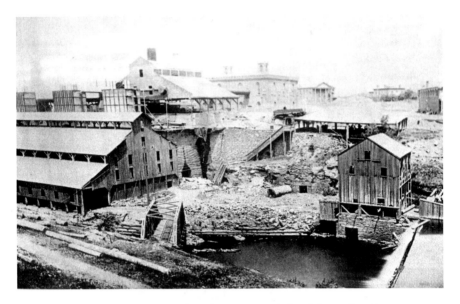

The Lackawanna Iron & Coal Company became a vast industrial complex of enormous blast furnaces, rolling mills and puddling mills. *Courtesy* Scranton Times-Tribune.

Hawkes recalled. "All comers had squatters' rights to build on the South Side near the furnaces. They built shanties in the woods and each shanty had a stone chimney. When a newcomer arrived, the neighbors would get together and build a house by sundown."[23] In 1841, the company hired Captain Scott of Carbondale to lay out a village on the south side of Roaring Brook. The Scrantons called their village Harrison, in honor of the president of the United States, who had died earlier in the year. The collection of rude dwellings soon came to be called Shanty Hill.[24]

The troubles for this fledgling enterprise were far from over, and it struggled to keep afloat until, in 1845, George Scranton became convinced that the company should begin to manufacture "T" rails for the railroad. So called because of their T-shaped profile, the rails were in great demand as the nation laid rail at a tremendous rate. The largest supplier of rails by far was England, and the waiting lists were long. The New York & Erie Railroad happened to be in a bind, of which George Scranton became aware. A relief act passed by the New York State legislature in 1845 required the NY&E to complete a connection between Piermont on the Hudson River and Binghamton by December 31, 1848—or forfeit state money in the amount of $3 million. With the English supply of rails in question, NY&E

president Benjamin Loder negotiated a contract with the Scrantons for the manufacture of four thousand tons of T rail at $65 per ton.[25] In 1847, the Lackawanna Works began to roll out T rail for this venture. The next year, two more blast furnaces were constructed. A fourth was added in 1853 and a fifth in 1857. Various changes were made along the way, and in 1857, the company installed its Bessemer converters, a move that allowed it to make steel rails instead of iron rails.[26]

———•———

RAILROADS: THE REGION'S LIFELINE

The success of the Lackawanna Iron & Coal Company came gradually, but the importance of that success cannot be overstated. It ensured the development of another industry in the growth of the Lackawanna Valley: railroads. Once again, the credit for this industrial venture goes to George Scranton, and his efforts would result in a vital network of both shipping and passenger lines that connected Scranton, its industries and its commerce to the nation. When George Scranton first came to the area, he traveled a series of roads that were little more than old Native American paths, widened to accommodate a wagon. The trip took two days. Scranton's keen business instincts—undoubtedly coupled with his experience making T rail—told him that railroads would be a pivotal factor in the industrial development of the region.

In 1849, Scranton turned his attention to a plan, in the works since 1832, to construct the Leggett's Gap Railroad. Scranton took over as general manager of that railroad in 1850. A merger with the Delaware & Cobbs Gap Railroad—which crossed the Pocono Mountains—resulted in the establishment of the Lackawanna & Western Railroad. It was the first railroad to run through the area that would become Scranton.[27] With his engineers, Scranton traveled every foot of the road. He oversaw its construction and equipment to the minutest detail. He also put the bulk of his private funds into the company. His efforts would prove vital to the region's development, as construction of the railroad from Scranton to Great Bend would allow the Lackawanna Railroad to connect with the New York & Erie. This would,

in turn, open the market for coal, allowing it to be shipped to western New York. In 1856, James Archbald took over as general agent of that company. During this time, the railroad's southern division was built. The next year, with the opening of the railroad to the Delaware River, Mr. Archbald took over as chief engineer. The line was extended to New York City. During the construction of this part of the line, Mr. Archbald undertook what is perhaps the most remarkable piece of engineering in his illustrious career. A tunnel was needed at Oxford, New Jersey. The topography of the area required something called a reverse curve. That means that the railroad line had to be built so that it resembled a letter S turned on its side. Its completion was regarded as a remarkable piece of engineering skill.

The new railroad would need locomotives, and the first one the company bought was the Pioneer. The first one in operation was the Spitfire. Both were English made. On May 16, 1851, railroad superintendent D.H. Dotterer took the Spitfire for its test run along the short distance from the Lackawanna Iron & Coal Company's iron mill to its furnace. As the first locomotive that many people had seen, it caused great excitement, and by the time it reached the iron furnaces, a number of men and boys had jumped aboard. Both the Pioneer and the Spitfire were small engines, used primarily for grading the road. On October 11, an engine called the Wyoming was connected to two passenger cars and taken for a trial run along the new road. The road to Great Bend officially opened on October 15, 1851. The train carried sixty-five people from Great Bend to Scranton,

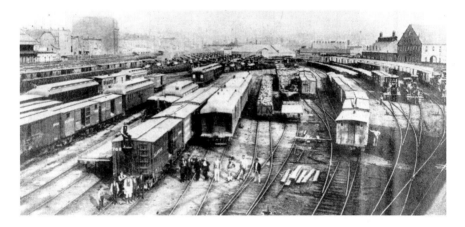

The DL&W rail yards, located behind the buildings on the south side of Lackawanna Avenue, during the 1877 labor strike. *Courtesy Lackawanna Historical Society.*

a distance of forty-eight miles, in two hours and forty-five minutes. The next day, the first coal train started for Ithaca, New York, and on October 20, regular passenger service began. The original passenger depot was located in the rear of the west corner of Lackawanna and Wyoming Avenues. The freight station fronted Washington Avenue.

In 1853, the company merged with the Delaware & Cobbs Gap to form the Delaware, Lackawanna & Western. Expansion was underway, and the railroad required a desirable grade that would allow it to continue southerly toward New York. On January 28, 1855, tracks were laid across the upper end of Lackawanna Avenue, and on May 10, the first locomotive ran through the tunnel near the Nay Aug falls. The continuation of this route allowed for access to New York City. This railroad provided unprecedented transportation opportunities for both goods and passengers. The DL&W was but one of a number of railroad lines that moved through Scranton. Among the largest were the Central Railroad of New Jersey, the Delaware & Hudson, the Ontario & Western and the Erie & Wyoming Valley Railroad. Together, they provided all-important freight and passenger transportation into and out of the city.

ANTHRACITE COAL: THE REIGNING KING

Anthracite's success was never a sure thing, not until two pioneering brothers, William and Maurice Wurts, came to the region from Philadelphia. They brought with them an ingenuity and determination that gave birth to the anthracite industry and propelled it to the forefront of America's Industrial Revolution. About 1812, the brothers began to explore the area around Providence in search of coal. Unable to buy land there, they traveled farther north, where they bought several thousand acres at three dollars per acre and founded Carbondale.

Called stone coal, anthracite was known among both native peoples and area settlers as early as the 1770s. But it met with two great obstacles: it could not be burned in existing stoves, and it was difficult to ship. The first problem was overcome in 1808 when Wilkes-Barre blacksmith Jesse Fell (later a judge)

invented a grate that allowed anthracite to be burned. Dr. Hollister recalls the event as follows:

> *In watching the light blue flame issuing from the furnace of his shop, made livelier by a draft of air from the hale lungs of a bellows, he conceived the idea of inaugurating a coal fire into an ordinary fire-place…In the leisure hour of an evening, he built up a jamb of brick work in an old fire-place in his house, upon which he placed four or five bars of common square iron, with a sufficient number up in front to hold wood and coal. He filled this contrivance with hard wood, after igniting which, he piled on a quantity of coal, sought his bed and was soon lost in slumber… Early in the morning as he awoke, he was astonished and cheered to witness the coal fire announcing its own unconscious achievement. That fire, kindling a glow of anthracite throughout the world, carried the name of Judge Fell down in history.*[28]

The Wurts brothers began to excavate coal in 1814, and in 1822, they began their coal operations. But anthracite's second obstacle—transportation—would not be overcome as easily. The brothers conceived a plan for a canal between the Delaware and Hudson Rivers. Its estimated cost was $1.3 million. Undeterred, the Wurts brothers formed a company called the President, Managers and Company of the Delaware and Hudson Canal Company, with capital of $1.5 million. The stock sold quickly. The D&H was the nation's first million-dollar corporation, and it launched the Lackawanna Valley into the anthracite age. It began shipping coal on its canal in 1829.[29]

The coal industry opened a new world of opportunity for any man who cared to invest in it. John Jermyn was one such man. Born in Rendham, Suffolk, England, in 1825, Jermyn came to the United States in 1847. From people in New York City, he heard of the opportunities opening up in the Lackawanna Valley. His first day's work in Scranton was cleaning up the lawn and mansion belonging to J.C. Platt, a partner in the Lackawanna Iron & Coal Company. He was paid seventy-five cents per day. But the opportunities the region afforded, combined with his hard work and smart business sense, took him from humble beginnings to a position of both wealth and influence. In the 1850s, Jermyn opened an exclusively retail mine, the first in the area. With two or three men, he worked the upper veins and sold his output to parties who came and carted it away. The mine became the foundation of what was one of the most extensive individual coal operations

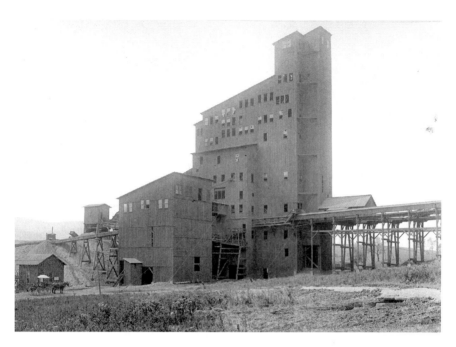

The Brisbin Colliery, owned by DL&W, began operations in 1875 and ceased in 1910. That year, it employed 744 workers. *Courtesy Lackawanna Historical Society.*

in the valley. Jermyn would buy and sell several mines in the area, but the largest of his operations was located in the borough of Old Forge. In 1851, Mr. Jermyn opened the first mine—the Diamond—for the Leggett's Gap Railroad Company, later the Lackawanna, and he himself mined the first ton of coal sent to market by that company.

The largest coal mining interests by far, however, were held not by independent miners like Jermyn, but by the big railroading companies. All the coal mining and shipping done in the Lackawanna Valley was done by the D&H up until 1851, except a small amount that was mined in Pittston. Between 1841 and 1872, 2.27 million tons of coal were produced from mines under the city of Scranton alone. The year 1872 saw just over 2.1 million tons of coal produced from Scranton mines. Figures from the Scranton Board of Trade reported that, in 1912, there were twenty-seven collieries (or coal breakers) in operation in the city of Scranton alone and eighty-four in the Lackawanna Valley. There were 33 mines in operation in Scranton and 167 in the valley. Production for those mines was 180 million tons in Scranton and 600 million in the valley. When Frederick Hitchcock prepared

his monumental *History of Scranton and Its People*, published in 1914, he asked geologist and mining engineer William Griffith to write several pages for the book. "The figures…are so enormous," Griffith wrote, "that it is difficult for the ordinary person to understand their true meaning." Griffith calculated the numbers this way: "If all the coal mined under the city of Scranton in one month were loaded into coal cars, it would make a continuous train which would reach from Scranton to New York City."

Coal was indeed king. It is important, though, to understand the interconnection among the three big industries that developed in the Lackawanna Valley. The Lackawanna Iron & Coal Company made iron T rails for the railroads. The LI&C also mined coal for its own use as a fuel source to manufacture iron. The railroads shipped both the iron products and the coal to market but also used anthracite coal as their fuel. These industries were so interdependent that indeed it is impossible to separate them. Furthermore, it is these industries that shaped the development of the Lackawanna Valley, not only directly but also indirectly in terms of other industries they attracted and in terms of an entire community of business, civic and social activity that formed upon the foundations laid by these industrial giants.[30]

THE WORK OF JAMES ARCHBALD

The role played by James Archbald in the development of the region's coal and railroading industries is significant enough to warrant a discussion of the man himself. Mr. Archbald came to Carbondale in 1828 to work for the Delaware & Hudson Canal Company. Born in Little Cumbray Isle, Buteshire, Scotland, on March 3, 1793, he was a self-educated man. When Mr. Archbald arrived, the D&H coal operations had been going for about six years, and the company was working to complete its canal from Honesdale to New York State. A civil and mining engineer, Mr. Archbald took charge of the engineering department of the D&H. His main goal was to build much of the railroad line that would cross Moosic Mountain. Meanwhile, Mr. Archbald and a Mr. Clarkeston discovered coal in the area that would become the borough of Archbald.

The D&H felled trees and erected a few rough dwellings among the stumps. "It was the wildest place in the coal field chosen for a habitation," according to Hollister. But development moved along at a rapid pace, with Mr. Archbald supervising much of it. In 1847, the D&H completed an extension of its gravity railroad to Archbald. But Mr. Archbald was far from through with his work. While still involved with the D&H, he engineered and superintended the building of a gravity railroad for the Pennsylvania Coal Company. The road went from Hawley to Pittston, a considerable distance, and one that would open up the coal operation still further. Mr. Archbald remained chief engineer for the DL&W until his death in 1870. During his tenure, the railroad was almost completely rebuilt. It was extended north to Binghamton and on to Oswego, New York, and Lake Ontario.[31]

INDUSTRY AND THE CIVIL WAR

Very little has been written about the Civil War and the region's iron, railroading and coal industries—a surprising fact, considering the place these industries had on the national stage. Scholar Grace Palladino, in her 1990 book *Another Civil War*, focuses on the relationship between anthracite coal and the war, but she confines her study to the southern coalfields of Schuylkill, southern Luzerne and Carbon Counties. Still, the fact remains that anthracite coal fueled factories, railroads and even steamships. Nothing is written to suggest that coal mining operations shut down in any great numbers during the war years. We can only assume that Scranton, like other anthracite communities to the south, kept up operations, supplying much-needed fuel to the war effort.[32] Scranton did, indeed, send its men to war. Colonel Ezra Ripple, one notable example, returned to write a memoir, *Dancing Along the Deadline: The Andersonville Memoir of a Prisoner of the Confederacy*. Ripple became mayor of Scranton. Two Lackawanna County residents—First Sergeant Patrick De Lacy and Sergeant John C. Delaney—received the Medal of Honor for their heroic service.[33]

The Dickson Works:
The Industry that Supported Industry

During the height of the nation's industrial era, local iron, coal and railroading giants found themselves on the national map. Indeed, the nation could not have run without them. They brought great wealth to their owners and stockholders and jobs to all levels of workers, from upper and middle management down to unskilled laborers. But these three giants drove the region's development in another way. From their success sprang a group of related industries—industries upon which they themselves relied. By 1871, Scranton had twenty-eight iron and steel furnaces, second only to Johnstown in national production. One of the largest of these manufacturers was the Dickson Manufacturing Company. Born in Leeds, England, in 1824, Thomas Dickson immigrated to Canada with his family and then on to the United States. In 1836, he found himself in Carbondale working as a mule driver for the Delaware & Hudson Railroad. In 1855, Thomas, John and George Dickson, along with Maurice and Charles Wurts and some others, founded their own company. The keen business eye of George Scranton saw the value of having such a company in Scranton, near his iron and coal company. He and his brother Selden persuaded the Dicksons to relocate to Scranton, and in 1856, the Dickson brothers and their partners built a foundry and machine shop along Penn Avenue.

With thirty employees, they tackled their first major contract: supplying the Delaware & Hudson Canal Company with engines and boilers for a new railroad over Moosic Mountain. Other contracts soon followed, and in 1862, the growing business was incorporated as the Dickson Manufacturing Company. The same year, it purchased the Cliff Works, an engine manufacturing company on Cliff Street near the DL&W rail yards. The small company turned out four or five steam locomotives per year, but business was about to boom. Within six years, the Dickson Works increased its operation to 350 employees. Two years later, the company bought the Kirlin Planing Mill, next to the Cliff Works, adding railroad cars, doors, sashes, blinds and other wood products to its line. In 1866, the company opened a foundry and machine shops in Wilkes-Barre and produced car wheels and axles.

At the start of the 1870s, Dickson Manufacturing was turning out five locomotives per month rather than five per year, as well as railroad cars and all classes of mining machinery. Flushed with success, the company rebuilt its Penn Avenue headquarters and shops in 1882. With a floor space of approximately twenty-nine thousand square feet, the structure included three floors of offices and two galleries, each twenty-five feet wide. The Dickson Manufacturing Company produced machinery that supported various industries, including mining, rolling mills, steelworks and waterworks—all industries that were growing and thriving in Scranton. It manufactured locomotives, stationary engines, blast furnaces and boilers. By 1890, it supplied industries across the nation. Within a few years, the Dickson was turning out one hundred locomotives per year. It dominated more than six acres and employed more than 1,200 workers.[34]

The Industrial Foundation Supports Further Industry

The city's three industrial giants—iron, coal and railroading—benefited the region in still another way. They formed an industrial foundation that would not only supply America, but would also make the area appealing to other industries. Coal provided an efficient and affordable energy source. The area's railroads provided transportation for products and finished goods. Scranton's founders knew that the key to the city's long-term success lay in two areas: careful management of the city's existing industries and expansion of new industrial and business interests. In December 1867, upstairs above the Fuller grocery store, thirteen men met around a potbellied stove to form the Merchants Association. Their goal was to encourage the growth of the city, enlarge its marketing area and ensure that overproduction of anthracite coal did not cause a slump in the market. The Scranton Board of Trade cited four things that made Scranton an attractive city for industrial interests: first, the availability of factory sites in locations convenient to railroads and within easy reach of the homes of employees; second, reasonable rates for water and fuel, including anthracite coal and electricity; third, a ready supply of labor; and fourth, plenty of progressive banks and other businesses.[35]

One of the industries that took notice of Scranton was the silk industry. Silk, lace and other so-called needle trades came to Scranton to take advantage of the cheap labor to be found in the persons of coal miners' wives and daughters. The wages paid these men were so low that the women and girls of coal mining families were forced to seek employment. Scranton's silk industry took off. Like other industries that found success here, it benefited from railroad lines that led into New York, cheap and abundant electricity and the ready supply of people willing to work at relatively low wages.

The manufacture of silk was a multistep process. A number of silk mills thrived in the city. Most did not do the complete job, from processing raw silk to making finished goods. The first step was to wash the raw silk in large vats. Next, the silk was wrung out and allowed to dry. This entire process was known as "throwing." The Klotz Throwing Mill in Scranton specialized in this process. From there, the silk went into the winding process.

The Scranton Silk Manufacturing Company made silk thread, or warp, which it sent to other mills for weaving. In 1879, the Sauquoit Mill, from Sauquoit, New York, bought and enlarged the Scranton Silk Mill. The company added a weaving center in 1885. By 1891, the Sauquoit operated 150 looms, and it took the lead in the local industry. In 1891, Sauquoit was the largest mill in the city. Superintended by Albert Harvey, it was the only mill in the city to manufacture silk fabrics. Each week, it turned out fifteen thousand yards of the finest-quality silk fabrics. The weaving department alone employed three hundred operators, all of them young women. The company sold its goods to New York, Philadelphia, Boston and Chicago and kept warehouses in each of those cities. In 1895, Scranton's silk industry expanded to include three silk weaving mills.[36]

While some of the city's industries remained relatively small, others moved to the national forefront. The Scranton Button Company is one example—and its owner is an example of a true rags-to-riches story. William Connell, born in 1827 of Scottish ancestry in Cape Breton, Nova Scotia, Canada, relocated to Scranton with his family. They were of little means, and the young William left school at age seven to work as a breaker boy to help support them. In 1856, he got his first real break when the Susquehanna & Wyoming Railroad and Coal Company put him in charge of a mine in Scranton. As a foreman, his exceptional ability became more and more apparent, and the company increasingly put more responsibility on his shoulders. During these years, Connell lived frugally, putting aside a portion of his earnings. By 1872, he supervised the operation of the entire mine. That year, the charter for the corporation expired, and Connell used

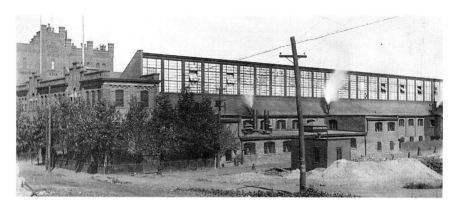

Klotz Throwing Mills. *Courtesy* Scranton Times-Tribune.

his savings to purchase the company. As his career advanced, he found himself on the board of directors of a number of companies, including the Scranton Button Company, founded in 1885. Connell purchased the fledgling company, and within a year it was doing a million dollars worth of business. In 1915, it turned out in excess of three million buttons per day. That number seems astoundingly large, even for a worldwide industry, until you consider what an important article the button was. In the age before the zipper, buttons were used on men's shirts, jackets and trousers and on women's and children's dresses. Shoes were buttoned up, as were some gloves. Buttons of distinction were worn on every conceivable type of uniform. Buttons were made of brass, gold, glass, ivory, shell and composite materials. In the late nineteenth century, buttons of extravagant design were a big part of fashion.

KEEPING IT COOL: ICE HARVESTING

Ice was once a necessity in homes, restaurants and businesses. The dairy, meat, beer and other industries relied on ice to both store and ship their products. The vast quantities of ice for home and commercial use came from natural sources. Locally, the ice business boomed in Gouldsboro, Tobyhanna, Greentown, Warnertown, Pocono Lake and other communities

in the Pocono region. The need for ice was so great that it was not uncommon to create man-made ponds or lakes by diverting streams to low areas or by damming a stream. When harvesting time came around, the ice fields were marked precisely before cutting began. The thickness of the ice determined the yield. Four inches of ice required 105.4 square feet of surface cutting spaces to get 1 ton of ice, whereas fourteen inches of ice required only 30.1 square feet of surface to get 1 ton. Prior to the 1920s, ice cutters used long saws with wide teeth to hand-cut blocks of ice. Horses hauled the cut ice to icehouses for storage. Later, motorized tractors and saws eased the work somewhat. In a good year, some 260,000 tons of ice could be harvested from Gouldsboro alone. Once cut, the ice had to be stored. Icehouses were impressive structures capable of storing great quantities of ice. A cubic foot of ice weighs about fifty-seven pounds. That means that between 40 and 50 cubic feet of space had to be allotted per 1 ton of ice. For adequate insulation, twelve inches had to be left between the walls of the icehouse and the blocks of ice. In Gouldsboro, the Klondike icehouse held 50,000 tons of ice. The icehouse known as Gouldsboro No. 1 held 42,000 tons, and Gouldsboro No. 2 held 22,000 tons. Railroad cars transported ice to market, and it was not uncommon for thirty cars to be loaded in a single day.[37]

ICS: "We Teach the World"

Industrial development required education, and Thomas J. Foster was a forerunner in the education of industrial workers. Foster came to Scranton in 1888. Prior to that, he served as publisher of the *Mining Herald*, a journal based in Shenandoah. In 1881, he started a column of questions and answers related to the types of problems that a mine foreman would have to be familiar with in order to pass the state examination. In 1883, Foster gathered the materials that had appeared in the column and put them together in a publication called *The Mine Foreman's Pocketbook*. This experience gave birth to a bigger idea in Mr. Foster's mind: to teach the subject of mining from its fundamentals—arithmetic, formulas, ventilation, methods of working, in fact the whole science of mining. Mr. Foster recognized that a miner's day was long and hard and that attending regular classes would be difficult.

His system of teaching was to be done entirely by correspondence methods. Thus, the International Correspondence School was born in Scranton. Foster and his new school developed instructional materials that were easy to read and to understand. He announced the new correspondence course in his mining journal. The first student, Mr. Thomas Coates, enrolled on October, 16, 1891. The school's original course led to a second, a course in mine surveying and mapping. As the method proved successful, the school expanded into other areas of study.

The International Correspondence School was the first of its kind in the world. In 1894, it occupied twenty-five offices in the Coal Exchange Building at 124 Wyoming Avenue. It employed fifty-five instructors and spent $10,000 annually in postage. It is credited with standardizing the practice of putting a return address in the upper-left corner of envelopes. The school offered courses in a wide range of subjects, including advertising, architecture, chemistry, civil engineering, commerce, drawing, electrical engineering, languages, commercial law, locomotive operations, mechanical engineering, navigation and other subjects. By January 1, 1914, its total enrollment was 1,651,765. Thomas Edison even designed a course for the school. The school produced all of its own course materials, including its own textbooks. On September 24, 1901, Foster's school was incorporated as the International Textbook Company, responsible for printing, binding, publishing and selling instruction papers, textbooks, periodicals, drawing plates and other products for its education programs. The school's motto, "We teach the world," was known around the globe.[38]

REMEMBER THE LADIES: WOMAN'S DOMESTIC INSTITUTE

The International Correspondence School branched into women's education in a significant way when, in 1916, the Woman's Domestic Institute of Arts and Sciences was established. This was the era of domestic sciences, when such topics as home canning were addressed from a scientific approach. The school offered courses that would help women perfect their cooking, sewing and other skills so that they could run a more efficient household, with attention to proper

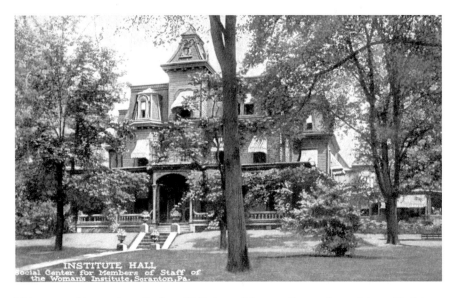

This postcard image shows Institute Hall, the social center for members of the staff of the Woman's Domestic Institute. *Courtesy Lackawanna Historical Society.*

nutrition and health. This was also an era when young working-class women were looking for a way to earn their living other than at the mill or the factory. The school offered "the way to a skilled trade or profession—with easier, pleasanter work at better pay—for thousands upon thousands of women and girls who earn their own living." The home study methods developed by the ICS worked well for these types of courses. Mary Brooks Picken was the early force behind the Woman's Domestic Institute. She took the position that women should wear only well-fitting clothes in styles that flattered them, regardless of what fashion dictated. That attitude helped make her a nationally known force in the fashion world. For the school, Ms. Brooks Picken wrote a series of course booklets on topics from plain dressmaking to lingerie, maternity clothes, clothes for infants and children, fancy dresses, tailored suits, coats, capes and millinery. She patented the Picken Square, a tool that uses a system of scales and curves for dressmaking. As a member of the National Academy of Sciences National Research Council Advisory Committee on Women's Clothing, she had a part in selecting Hattie Carnegie as the designer of the United States Army's women's uniform. Mrs. Brooks Picken's advice and assistance went into all aspects of the women's uniform beginning in 1949. Brooks Picken authored ninety-six books on home sewing and decorating. Many of them were written right here in Scranton, for the Woman's Domestic Institute.[39]

THEY BUILT BETTER THAN THEY KNEW

SLOCUM HOLLOW GROWS

Industry brought change to the city at a rapid pace. The few rough buildings that made up the Hollow gave way to enormous blast furnaces and a vast industrial complex. In just a few decades, a building boom would transform Scranton into a city of exquisite architecture, modern innovation and cosmopolitan flair. During the Slocum family's time, a humble one-and-a-half-story frame house, home of Elisha Hitchcock, once stood on the old Dunmore Road at what is now the corner of Monroe Avenue and Linden Street. When the Lackawanna Iron & Coal Company made its mark, the home stood surrounded by 220 acres of farmland. But industry drew men to the area in growing numbers. Soon, Shanty Hill—the enclave of houses that had sprung up on the south side of Roaring Brook—was not enough to accommodate their needs. The Scranton brothers, George and Selden, hired civil engineer and architect Joel Amsden to lay out a pioneer town in the wilderness. Amsden laid out Lackawanna Avenue as the main thoroughfare. The stately residence of George W. Scranton graced the spot on the northwest corner of Lackawanna and Adams Avenues (the spot where the Hotel Casey would later stand). From his front windows, George Scranton could see his Lackawanna Iron & Coal Company.

By the 1850s, the population numbered in the hundreds. Homes and businesses lined the streets. George Scranton owned most of the block along Adams Avenue to Spruce Street. He could leave his home and walk the short distance to his iron furnaces. Within a block or so, the small city contained everything its residents needed. Dowd's hardware store occupied a spot on Lackawanna Avenue just down the block from Mr. Scranton's home. Just across Lackawanna Avenue was Jifkin's butcher shop. Charles Schlayer operated his bakery down one block on Washington Avenue, between Lackawanna and Spruce. G.W. Masser, the doctor, was located in that block, and Dr. Boyd the druggist was right there, too. The Methodist Episcopal church stood across Adams Avenue from George Scranton's residence. Many of Mr. Scranton's neighbors were employees of the Lackawanna Iron & Coal Company. Superintendent Mattes lived on Jefferson Avenue. John F. Davis, furnace manager, lived on Wyoming Avenue. Mr. Mannes, superintendent of the company's lumber department, was right next door to Dowd's hardware store. The land agent, the dentist and the tax man were all within a block or two, as were the carpenter and the furniture dealer. The horse was crucial to life, and the land along Adams toward Spruce Street was home to a stable. Another stable stood on the corner of Wyoming Avenue and Spruce Street.[40]

In 1857, Elisha Hitchcock gained a neighbor when James Archbald, then with the Delaware & Cobbs Gap Railroad, built Archbald Place at the corner of Ridge Row and Monroe Avenue. This area marked the farthest eastern edge of Scranton's residential section.

At the same time, other men were clearing the forest and establishing homes and businesses. When he arrived in Slocum Hollow in the 1840s, Charles Fuller "built a comfortable residence in the dense forest" on the east side of Penn Avenue, about one hundred yards north of the corner of Spruce Street. Fuller's life epitomizes that of a generation of men who helped transform the wilderness of the Lackawanna Valley into first a pioneer town and then an industrial center. Fuller came to the area to take the job as secretary of the Delaware & Cobbs Gap Railroad.

Fuller and the others like him came to try their hand at brand-new industries. They came to make money. But they also came to settle, and that meant building a community. Their budding town had little and needed everything, and the people who moved into it wasted no time in taking care of those needs. Fuller was an early member of the town's Presbyterian church and became a ruling elder in 1848. He occupied that office for thirty-three years, until his death in 1881. Elisha Hitchcock was a founding member of

They Built Better than They Knew

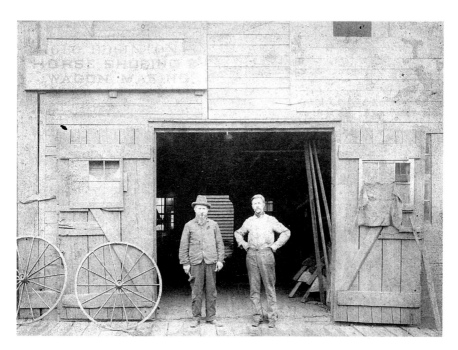

This undated photo shows George Edington, *right*, in front of his business on West Lackawanna and Sixth Avenues with Charles Burdett Sr. *Courtesy* Scranton Times-Tribune.

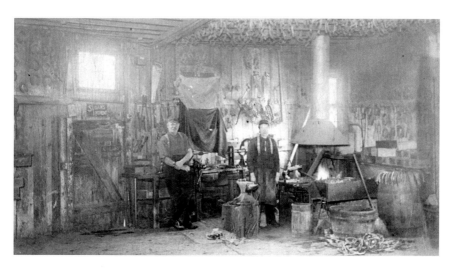

This rare photograph shows Ruben Gardner, left, inside his blacksmith shop. His helper stands at the right. *Courtesy Lackawanna Historical Society.*

The Neptune Fire House was the city's first. *Courtesy* Scranton Times-Tribune.

St. Luke's Episcopal Church. That congregation came about shortly after the Reverend John Long answered the call to leave Montrose and begin preaching in the burgeoning community near the LI&C. The needs of the people were many, not only the spiritual but also the material. George Fuller followed his older brother to Scranton in 1856. A printer by trade, he opened

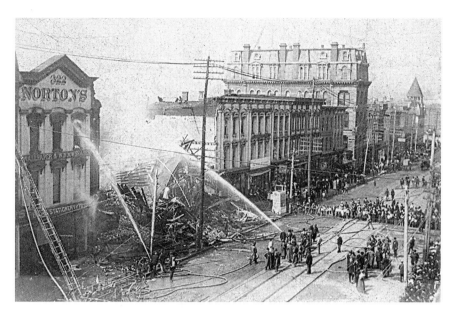

Scranton firemen battle a blaze seen on February 7, 1901. Fifty employees of the DL&W accounting office were evacuated. *Courtesy* Scranton Times-Tribune.

a grocery store on Lackawanna Avenue and later built a substantial brick structure on the southeast corner of Wyoming and Lackawanna Avenues. The store operated for years, and when George's son joined the business, the firm name became G.A. & I.F. Fuller & Company. The first bank—First, Mason, Meylert & Company—opened on the northwest corner of Wyoming Avenue and Centre Street early in 1855.

The town's first fire company, the Neptune, was organized by Charley Roessler, a barber by trade. The Neptune's first firehouse was a small frame structure containing the first old-style hand-pumping fire engine in Scranton. It stood on the south side of Lackawanna Avenue, just above Adams. These were the days of wood stoves, candles and gas lamps, and fire posed a serious threat to life and property. Charles Fuller started one of the first fire insurance businesses here. Later, his son John joined the business, and they called the firm Charles Fuller & Son.[41]

The town was changing. Hitchcock sold his farm to George Sanderson in 1855, and the land was destined to be developed as the town grew. Scranton was incorporated as a borough on February 14, 1856. By 1857, the population of Scranton numbered in the hundreds. The men who came to work in the city's earliest industries came primarily from Wales, England,

Billy Walter's Wigwam, a saloon, and Parker's Pool Hall in the 200 block of Lackawanna Avenue offered amusement to Scranton's hardworking men. *Courtesy* Scranton Times-Tribune.

Ireland and Germany. The Welsh knew the iron and mining businesses. These early settlers found diversion in shooting pool, shooting squirrels and volunteering for the local fire company. But those early days also brought wealth and with it palatial homes, barbershops with hot towels and fancy beauty salons. Stores displayed the latest Paris fashions, and the Forest House hotel offered sizzling steaks a la Delmonico, a new dining favorite. Vaudeville shows, riding clubs, the bicycle club and the engineer's club all offered pastimes for prosperous residents.

A City Is Born

The 1860 census shows a population of 9,223. But mills, factories and mines were bringing thousands of people to the borough of Scranton. It was growing at a faster rate than nearby boroughs of Providence and Hyde Park, both of which sat on the opposite side of the Lackawanna River. In fact, Providence was separated from Scranton by a mile and a half of land that was virtually vacant. It was not until 1870 that Providence saw a railroad. The 1870 census shows a population of 35,092 for the borough of Scranton, a gain of 25,869 in the decade between 1860 and 1870.

Limited transportation kept Scranton's wealthiest citizens in the center of the city. The eastern hill was virtually undeveloped, and Petersburg was a suburban village inhabited mostly by German immigrants. As business

Tracks for horse-drawn streetcars are visible along Lackawanna and North Washington Avenues, circa 1880s. *Courtesy* Scranton Times-Tribune.

Victor Burschel of Dunmore designed the city's first flag for a contest sponsored by the *Scranton Times. Courtesy Lackawanna Historical Society.*

and industry increased, and as more and more people began to move into Scranton, the heart of the city gave itself over to commerce, civic buildings, theatres and restaurants. Residents began to move into the "outskirts"—farther up the hill and into Green Ridge. Slocum Hollow had grown into the borough of Scranton. On April 23, 1866, the boroughs of Scranton, Hyde Park and Providence were organized by a special charter as the city of Scranton. The new city covered an area of 19.6 square miles. The charter set up a mayor's court, which was a court of record, with substantially the same powers and jurisdiction as the regular county courts.[42] The city was still part of Luzerne County. E.S.M. Hill, an attorney and editor of two legal journals, served as Scranton's first mayor. In 1886, ground was broken for city hall at the corner of North Washington Avenue and Mulberry Street. Architects Edwin L. Walter and Frederick Lord Brown designed a proud Gothic structure, and Conrad Schroeder's firm built it of native West Mountain stone. The building, completed in 1888, housed the city's offices.[43]

They Built Better than They Knew

As Scranton grew, it remained at the forefront of innovation. One excellent example of this fact is the introduction of the telephone. In 1878, Richard O'Brien oversaw the installation of a telephone line between the Lackawanna Railroad's Scranton shops and its Nicholson station. O'Brien first saw the telephone when he gathered with a crowd of people at the 1876 Centennial Exposition in Philadelphia and watched as Alexander Graham Bell demonstrated his new invention. Much taken with the ingenious device, O'Brien spent the next three years preparing to introduce it to the city of Scranton. He obtained early versions of the telephone. Then he strung a line from the Western Union telegraph office, located at the southwest corner of Lackawanna and Penn Avenues, to the office of his brother, Dr. John O'Brien, located in the Howley Building on Wyoming Avenue, and from there to the nearby residence of Bishop O'Hara.

The role the telephone was destined to take in both the personal and commercial lives of Americans was scarcely imagined. But Richard O'Brien understood it as more than a curiosity. His work with the telegraph, especially during the Civil War, taught him the importance of long-distance communication. So when O'Brien approached William F. Hallstead, general superintendent of the Lackawanna Railroad, about installing an experimental telephone line, Hallstead agreed. In 1879, O'Brien gave a public demonstration of this telephone. That same year, under his direction, more lines were strung and an exchange system was built. James Merrihew, superintendent for Western Union, was one of several men who bought shares in the new company. In those early days, there were still a limited number of subscribers to the telephone. In January 1880, the company supplied service to thirty-five families. The following year, it was chartered as Scranton Bell Telephone Company, with capital of $150,000. Some subscribers purchased telephones and then sold tickets for their use—the precursors to the later coin-operated pay telephones. These early pay telephones could be found downtown on Lackawanna Avenue, as well as in Hyde Park, Providence and Dunmore.

The telephone exchange was located at 305 Lackawanna Avenue, over Fuller's drugstore. Telephone operators were young men or boys, undoubtedly excited at the chance to work with this new device. By the time the company came to the end of its first month in business, it had sixty subscribers, most of whom paid a whopping $4.50 per month for the service. But the new invention that had captivated Richard O'Brien in 1876 was well on its way to becoming a mainstay in households throughout the Lackawanna Valley.[44]

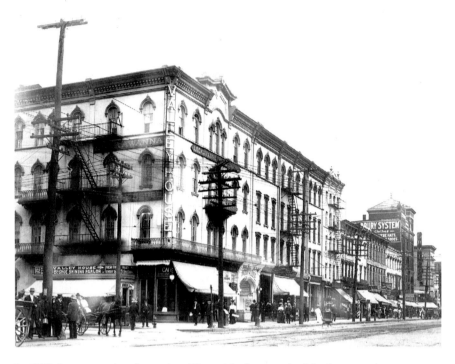

In 1899, Scranton enjoyed a modern life, as this photograph of Lackawanna Avenue, looking east, shows. The Valley House hotel is pictured. *Courtesy* Scranton Times-Tribune.

A look at the Scranton Gas and Water Company provides a sense of both the rapid nature of the city's growth and the way that growth was managed by its citizens. The company was organized by Joseph H. Scranton in 1854 with a capital of $100,000 because, it was realized, the borough of Scranton must have a water source. With its public stocks, it was considered a doubtful venture. Even so, measures were taken to prepare a system to meet not only present but also future needs of the citizens. A six-inch water main was installed along Lackawanna Avenue, and a distributing reservoir was built at the corner of Madison Avenue and Olive Street, just above where Elisha Hitchcock's farm was located. Water was pumped from the Lackawanna River into this reservoir. Its capacity was one million gallons, and its one main on Lackawanna Avenue provided enough force to enable the new fire company to throw a stream of water over any of the city's structures. The Wyoming House, at three stories, was the highest. This system, it was thought, would prove adequate far enough into Scranton's future. But it did not. In fact, the company had trouble keeping up with the demands of the increasing population. The company continued to grow,

and under the direction of William Walker Scranton, Joseph H. Scranton's son, it built new reservoirs, including the one at Lake Scranton, built in 1898. In 1900, the population of Scranton passed the 100,000 mark. By 1914, with the population near its peak of 150,000, the company had investments upward of $10 million in its watersheds and distribution plant. That year, the company's water system included twenty-three reservoirs with a capacity of seven million gallons. Its supply mains were thirty-six inches in diameter or six times the diameter of the one original main. Where only one main had existed—along Lackawanna Avenue—by 1914 water mains bisected the city. This company serves as just one illustration of Scranton's growth.

An Era of Landmarks: Hotels and Department Stores

Every city has its landmarks—iconic structures that ground the city in its roots and provide a sense of permanence. The decade 1880 to 1890 brought the electric streetcar, the telephone, electric lights and street paving, and Scranton hit its stride. As construction practices modernized, tall buildings emerged downtown—its first skyscrapers, as these multistory buildings were called. The Scranton Board of Trade, the organization that had begun above Fuller's grocery store as the Merchants Association, moved into the city's first skyscraper, located on Linden Street, in 1896. As the city grew, other landmarks emerged: Central High School, the Albright Memorial Library and the Delaware, Lackawanna & Western's passenger station, among others.

John Jermyn—the English immigrant whose coal dealings are detailed in the second chapter—owned extensive real estate holdings and built two of the city's prominent buildings. In 1885, Jermyn erected the Coal Exchange building in the 100 block of Wyoming Avenue across from the Globe Store's famous site. One of the city's first office buildings, it was designed by architect John Duckworth and constructed by Conrad Schroeder. The building housed various coal company offices, but the Young Men's Christian Association had rooms there for a period beginning in 1872, and the Scranton Board of Trade had its offices there for a period beginning in April 1882.

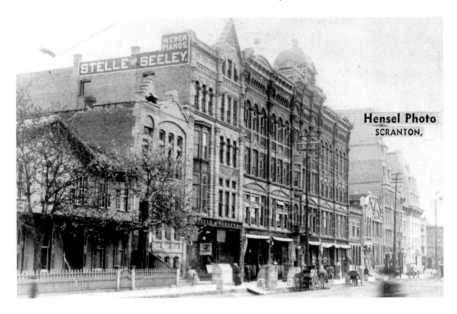

The Coal Exchange building, in the 100 block of Wyoming Avenue, was one of the city's first office buildings. *Courtesy Lackawanna Historical Society.*

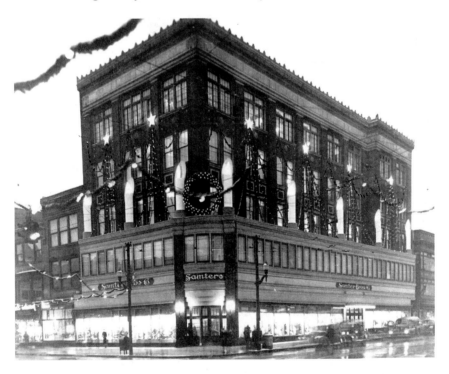

Samter's clothing store appears decked out for the holidays sometime about 1940. *Courtesy* Scranton Times-Tribune.

The Hotel Jermyn opened in 1895 on the site where the Forest House hotel had once stood—at the northwest corner of Wyoming Avenue and Spruce Streets in the heart of the city. Forest House had been so named because builders had cut through dense forest to erect it. George R. Sprague built this three-story wooden structure in about 1855, lived in it and ran it as a boardinghouse. In 1857, Joseph Godfrey bought the place and began to operate it as a regular hotel. Under his management, Forest House became a popular establishment—so popular, in fact, that he added a fourth story. But the city was growing and changing. Jermyn razed Forest House and erected his new hotel,[45] again hiring John Duckworth and Conrad Schroeder. The seven-story Romanesque structure was built to be fireproof. Even its doors and furnishings were metal. Jermyn hired Mr. Godfrey of the old Forest House to manage the hotel. Some ten thousand people attended its opening.

Another hotel—Wyoming House, the city's first, at the northeast corner of Lackawanna and Wyoming Avenues—came down to make way for Jonas Long's Sons department store about 1898. As the city grew, the old dry goods stores saw newer, larger versions. Long's was one, and another was the Globe Store. Founded by John Cleland and John Simpson in 1878, the Globe dominated the middle of the 100 block of Wyoming Avenue for decades. Long's became Scranton Dry Goods in 1917, and it and the Globe Store were the city's finest department stores.

A County Is Born

In the midst of this building boom, certain residents of Scranton were putting their attention on development of another kind: the formation of a new county. The northern end of Luzerne County—the area that included Scranton and Carbondale—was a considerable distance to Wilkes-Barre, the Luzerne County seat. By the routes of the day, Carbondale was thirty-six miles away, and Scranton was twenty. Travel was inconvenient. Before 1861, it was horse, or horse and carriage. From 1861 into the 1870s, just one railroad, the Lackawanna & Bloomsburg, ran between Scranton and Kingston, with only one train per day running each way. That left Scranton at 6:00 a.m. In

Kingston, a bus (presumably horse-drawn) carried passengers across the river and over muddy, slushy roads to Wilkes-Barre. The return train left Kingston at 6:00 p.m. People had to travel to the county courthouse for court trials and legal judgments and to record deeds, enter mortgage records or do business at Orphan's Court. Travel conditions not only caused considerable inconvenience but also cost a good deal of money, especially for those whose business might keep them tied up for days, or even weeks, at a time.

The push to establish a new county began in 1839. William Merrifield introduced a bill to the statehouse in 1844, but Senator William Ross of Wilkes-Barre fiercely opposed creation of a new county. Finally, on August 13, 1878, the citizens voted to establish a new county by a vote of 11,601 to 9,615. On August 21, the governor issued a proclamation that officially established Lackawanna County. The name was suitable, as the whole region had been known as "Lackawanna" for many years. The new county set up offices, rent free, in Washington Hall at the corner of Lackawanna and Penn Avenues. The Lackawanna Iron & Coal Company and the Susquehanna & Wyoming Valley Railroad donated land for a new courthouse, and a contest was held for a building design. Binghamton architect I.G. Perry won, and ground was broken on April 14, 1881. The land had been a swamp known as the Lily Pond. Crews dug an average of thirty feet to solid ground, and the land was filled with waste rock from the Lackawanna Iron & Coal Company. The cornerstone was laid with an impressive ceremony. Made of native West Mountain stone, the Gothic structure with Flemish details became the crowning jewel of Scranton.[46] In the style of the time, the courthouse was set in the center of a city block and surrounded with a parklike landscape that would include monuments and benches. It was the transformation of this swamp to the center of the city's life that moved Frederick Hitchcock to write, "They built better than they knew."

HOMES IN THE HILL SECTION

With central Scranton in the midst of a building boom, some of its wealthiest businessmen began to develop the Hill Section. Residents here took

advantage of views, enjoyed greater privacy than center city afforded and escaped the smoke and soot of industry. Where John Jermyn, the coal and real estate developer, had made his home right downtown at the corner of Jefferson Avenue and Vine Street, his son, John J. Jermyn, built a home that commanded the block bounded by North Webster and Taylor Avenues and Olive and Pine Streets. The pillars of his Classical Revival home could be seen from most any vantage point in the city. Another spectacular residence was that of Frank Carlucci, an Italian stone worker who had worked on the Hotel Jermyn, Elm Park Methodist Church, Lackawanna County Jail, Luzerne County Courthouse, the Nicholson Viaduct and many other impressive structures, as well as the Columbus and the George Washington Monuments on Courthouse Square. Carlucci's home at 1048 Clay Avenue reflected the grandeur of his other work around the community.

As businesses and industries thrived, Scranton's population continued to grow. The decade 1900 to 1910 saw a population increase of twenty-seven

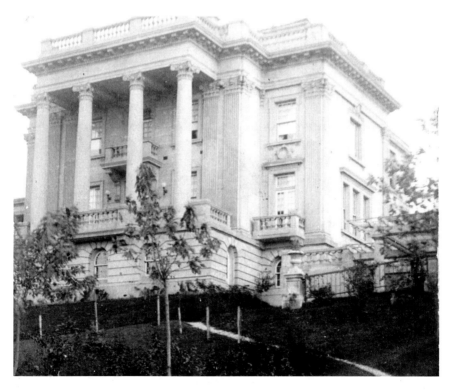

The home of Frank Carlucci at Clay Avenue and Poplar Street was built in 1905. *Courtesy Lackawanna Historical Society.*

thousand. The Hill began to change as upper-middle-class families moved in. Some of the larger estates were divided. John Jermyn portioned a section of his full block so that his daughter and her husband could build a Colonial Revival–style home on Pine Street and Taylor Avenue. The home, which still stands, indicates a high level of living, but it is not the mansion that Jermyn built. As the neighborhood continued to change, some estates were divided to make homes of a more modest stature for clerks, bookkeepers, teachers and other professionals. Land was at a premium, and homes were built close together. In the early 1900s, successful Jewish and Catholic families moved into the neighborhood.

LACKAWANNA COUNTY JAIL

Of course, the growing city was not without crime, and in 1885, Lackawanna County purchased land on North Washington Avenue at New York Street for a new jail. Scranton architect E.L. Walter was hired to draw up the plans and specifications for a modern jail. The grand jury and the State Board of Public Charities approved his plan and awarded him the contract in the autumn of 1885. Conrad Schroeder was hired as builder. The structure was built of brick, faced with West Mountain stone, and was completed and occupied in the fall of 1886 at a net cost of $116,441.63. It was an impressive complex. The space enclosed by the outer wall was 350 feet by 227 feet; the wall was 25 feet high; and the cell building was 46 feet by 200 feet, with a wing 50 feet by 46 feet. The jail had two tiers of cells, ninety-two in all, with space for forty more in the basement. Each cell was made of solid concrete floor, sides and ceilings and measured 9 by 12 feet, by 9 feet high, with outside light. The administration building was 45 by 90 feet, two stories and basement.[47]

Albright Memorial Library

Scranton was indeed building better than it knew, and not just structures, but institutions—places that would enrich the city and the lives of the people who lived in it. No better example can be found than the Albright Memorial Library. In a letter to the Scranton Board of Trade dated January 24, 1890, members of the Albright family explain their wish "to provide a suitable literary and educational element not heretofore supplied, for the elevation of the people of all classes." Toward that end, they donated the home of their late parents, which stood on the corner of Vine Street and North Washington Avenue. Joseph Albright Sr. had come to Scranton in the 1850s and worked for the Lackawanna Railroad Company as its first general coal agent, a position that placed him in charge of developing the railroad company's mining interests. Albright also helped organize the First National Bank of Scranton and served as a member of its board until his death in 1890. In yet another example of a city whose stately residences were giving way to commercial civic establishments, the home was razed, and Joseph Albright Jr. supplied the money to erect the library building.

By modern standards, the building is far more than "suitable." Designed after the Musee Cluny in Paris, the French Gothic structure is graced with ornate arches, heavy stone and black Spanish roof tiles that convey a sense of grandeur befitting the ideals expressed in the Albright letter. Joseph Jr. put so much emphasis on the structure itself that he quickly exceeded his budget of $50,000 to $75,000. Before he was finished, he ended up spending $125,000 for what he termed "a suitable building." A man who came from wealth and made large sums of money, he died with almost nothing, having put his wealth into philanthropic projects of this sort. A kind of secular cathedral, the Albright contains stained-glass windows and a grand public reading room that provides an ideal setting for the elevation of the human mind. Focusing on the structure, Mr. Albright left the citizens of Scranton to fill it with materials. Donation records list gifts from many prominent citizens, including the Scranton family. At the end of its first five years, the building housed between thirty-five and forty thousand items. As the Albrights intended, anyone—coal baron, miner, factory owner, millworker, housewife or student—could access the written word. Classical fiction, philosophy, law, natural science and many other topics were available to those who wished to explore them.[48]

Watres Armory

"The American citizen soldier—the volunteer—has had to fight the battles of his country in every war in which we have engaged." These words of Colonel Frederick L. Hitchcock are just as true today as they were when he penned them in 1914. Having served in the Civil War, Colonel Hitchcock came home to play a role in the formation of the City Guard. Originating during the labor riots of 1877, it would play a significant role in labor unrest throughout the state. Shortly after the 1877 riots in Scranton, Governor Hartranft authorized the transformation of the City Guard into the 13th Regiment of the Pennsylvania National Guard. As fast as they could write their names, two hundred men enrolled—enough to form four companies. Henry Boies, president of the Moosic Powder Company, was first in line. He commanded the battalion. Frederick L. Hitchcock served as first lieutenant and adjutant. The 13th Regiment was first called into active service in 1892, under the command of Colonel Ezra Ripple. The members were sent to Homestead, near Pittsburgh, to assist in quelling a labor riot. They assisted in similar disputes in later years.

In 1878, the 13th Regiment set up its first armory in the 300 block of Adams Avenue. In 1901, it moved into its new home—a Romanesque fortress designed by Lansing Holden.[49] This group of citizen soldiers has distinguished itself in every major conflict in which this country has engaged, dating back to the Spanish-American War. At the opening of World War I, the 3rd Brigade, 28th Division of the Pennsylvania National Guard, was designated. Locally, the 109th was formed, and included the 13th Regiment and the 1st Regiment, Philadelphia. It took part in six major campaigns in France and Belgium. Its ferocity in combat led General John Pershing, commander of the American Expeditionary Force, to dub the 28th the "Iron Division." It suffered more than fourteen thousand casualties.

In 1941, with war again raging through Europe, the 28th Division was ordered into federal service. Ten months later, Japanese forces attacked Pearl Harbor. With America now embroiled in World War II, the division trained extensively, both at home and in Britain. Just after D-Day, the 28th landed in France, fought through Normandy and helped liberate Paris. In November

1944, it found itself bitterly engaged in Germany. One month later, during the Battle of the Bulge, the division helped stall the last German offensive of the war. That war took two thousand of the 28th's men. Its fierce fighting and heavy casualties earned it the nickname "Bloody Bucket," the red Keystone insignia likened to a bucket of blood. The Pennsylvania National Guard saw active duty again in the Korean conflict. During the Vietnam era, the Pennsylvania Air National Guard (formally established in 1947) flew 134 supply missions to Vietnam, making it the first reserve air force ever to enter a combat zone without actually being mobilized. That era saw another reorganization. In 1967, the 3rd Brigade became the 55th Brigade, with Scranton as its headquarters. It was one of the few reserve units in the nation with maximum organization and equipment for an outfit that was capable of moving swiftly in any crisis. It could put troops on the road within an hour of an emergency call.

From Grenada to Operations Desert Storm and Desert Shield to parts of the former Soviet Union and elsewhere, these soldiers have gone where duty has required. During the Agnes flood in 1972, nearly thirteen thousand guardsmen were activated throughout the state. They were called on heavily to fight in the Middle East in this century. Time and time again, this group of citizen soldiers has answered the call, and time and time again, they have proven their mettle.[50]

Delaware, Lackawanna & Western Passenger Station

Another of the city's great landmarks appeared on the landscape in 1908. A few years earlier, DL&W president William Truesdale had authorized construction of a new passenger station, to be set at the south end of central city on grounds that had once belonged to the Lackawanna Iron & Coal Company. By this point, the DL&W had earned a reputation as one of the most efficiently managed railroads in the country. Its famous Phoebe Snow campaigns invited travelers to ride in a clean, stylish environment, and the railroad had outgrown its old passenger station at the other end

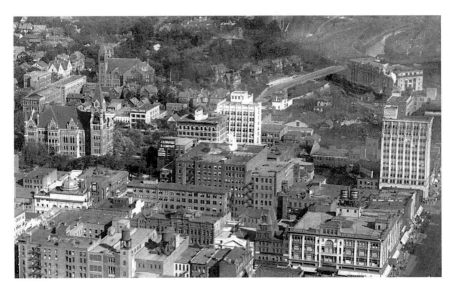

This aerial photograph shows some of Scranton's prominent landmarks: the Lackawanna County Courthouse, Elm Park Methodist Church and the DL&W Passenger Station. *Courtesy* Scranton Times-Tribune.

of Lackawanna Avenue, facing Franklin Avenue. The company hired New York architect Kenneth Murchison, who designed a French Renaissance–style building, considered one of the most beautiful rail passenger stations in the country. The two-and-a-half-story waiting room featured Sienna marble, a barrel-vaulted ceiling with a leaded-glass skylight and a series of panels depicting scenes along the railroad's passenger route between Hoboken, New Jersey, and Buffalo, New York.[51]

HOTEL CASEY

Until it was demolished, it seemed that this center of elegance had always stood proudly on its downtown Scranton corner. But it was not until 1910 that Andrew J. and P.J. Casey began construction of their hotel at the corner of Lackawanna and Adams Avenues—on the site where George

Scranton's stately home had once stood. The Casey brothers' tale is an immigrant success story. Andrew J. Casey arrived in Scranton in 1872. His brothers Lawrence and Timothy were already here and had established a wholesale liquor business on Penn Avenue. Within a few years, both brothers had died, leaving Andrew the sole proprietor. In 1887, his younger brother Patrick joined him, and in 1890, the Casey brothers moved their business to Lackawanna Avenue. By this time, they had become one of the largest wholesale distributors in the area, carrying whiskies, wines, cordials, clarets, bitters and, of course, beers. In 1892, the Casey brothers went into partnership with William Kelly and established their own brewery, located at Remington Avenue and Locust Street in Scranton's South Side, called Casey and Kelly Brewing Company. In 1897, they joined with E. Robinson's Sons to form Pennsylvania Central Brewing Company.[52] Like many of the city's entrepreneurs, the Caseys also got into banking. Patrick served as president of Liberty Discount and Savings Bank of Carbondale. Andrew served as president of Merchants and Mechanics Bank of Scranton and on the City Planning Commission. But the Caseys were destined to be remembered by the hotel. The eleven-story establishment for business opened on January 1, 1911. Managed by Milton W. Roblee, its sumptuous décor and excellent food were said to rival the best hotels in the biggest cities in the country.[53] The hotel flourished, and its reputation would last for generations. The Casey was *the* place to stay for entertainers, business tycoons and foreign dignitaries who came to the city. The Hotel Casey helped change the face of a growing Scranton. For many years, this emblem of luxury stood as a proud testament to the prosperity of this city and its business endeavors.

Scranton Times

The Lackawanna Valley got its first press in Carbondale in 1844. The *Providence Mirror and Lackawannian* was published, with Frank B. Woodward as its editor.[54] But the really big newspapers would not come on the scene for a few decades. In 1856, Theodore Smith started the *Scranton Republican*.

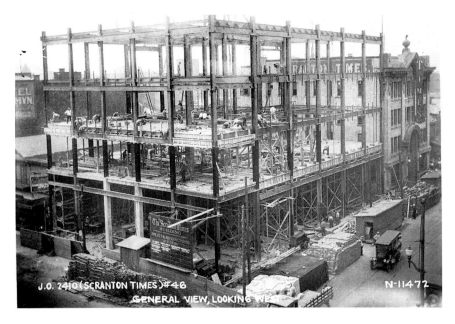

The *Scranton Times* new building under construction. With its radio tower, it became a landmark. *Courtesy* Scranton Times-Tribune.

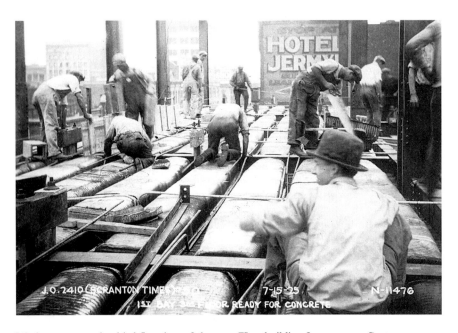

Workers prepare the third-floor bay of the new *Times* building for concrete. *Courtesy* Scranton Times-Tribune.

First published from an office on Lackawanna Avenue, the *Republican* started as a weekly but quickly became the city's first morning daily newspaper. It passed into various other hands during its tenure as one of the city's most important newspapers, but it eventually came into the hands of Joseph H. Scranton, who gave it to his son, Joseph A. Scranton. The *Scranton Times* came into existence in 1869 when attorney John Handley bought an existing newspaper, the *Register*. The *Times*, like the *Tribune*, had Democratic leanings. It introduced the penny newspaper to the city and, in 1894, changed from a morning to an evening paper. At the time, the *Truth* was the leading evening newspaper in the city. That same year, E.J. Lynett bought the *Times*, and the family has maintained ownership. It is the only newspaper to have survived into the present time. On May 21, 1990, the *Times* purchased the *Tribune* to become the *Times-Tribune*.

CONRAD SCHROEDER: THE MAN WHO BUILT SCRANTON

Scranton was indeed building better than it knew. City hall opened in 1888, the Albright Memorial Library in 1893, the Hotel Jermyn in 1895 and Scranton High School (later Central High School) in 1896. Noble structures that still define Scranton's cityscape, they all have one man in common: the builder, Conrad Schroeder. Any discussion of Scranton's development would be remiss if it omitted a note about the work of this remarkable man. This was an era when the city was building, and Schroeder was the man building it. Like many others who made their marks in Scranton, Schroeder was an immigrant. Born in Guntersblum, Germany, in 1846, he arrived in America in 1865 at the age of nineteen and settled in Scranton in 1866. Along the way, this enterprising man learned the building trade, and in 1870 he started his own contracting firm.[55]

And what a firm it was. From offices in the Connell Building, which he also erected, Schroeder employed, on average, four hundred workers. Schroeder's firm built large. The Scranton Board of Trade building (famous in the twenty-first century for its newly restored "Electric City" sign) and the Mears building were the city's first skyscrapers. The Pennsylvania Oral School

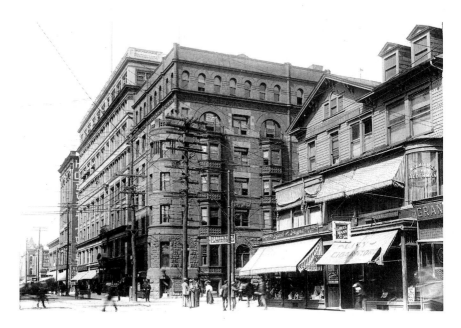

This circa 1904 photograph, corner of North Washington Avenue and Spruce Street, depicts a changing city with tall buildings alongside former homes. *Courtesy* Scranton Times-Tribune.

for the Deaf and the Robinson brewery were among the most sprawling complexes in the city, and Elm Park Methodist Church and Green Ridge Presbyterian are among the most impressive in a city full of notable churches. The Lackawanna Mills and Klots Mills, Sauquoit Silk Mill, Delaware & Hudson Railroad depot, Trader's Bank, Lackawanna Trust and Safe Deposit Company, County Savings Bank and Trust Company, Lackawanna County Jail, Moses Taylor Hospital, Hickory Street Presbyterian Church, Mount St. Mary's Academy and Public Schools 12, 22 and 33 were among the many built by this extraordinary company. The firm also built numerous estate homes for Scranton's wealthy industrialists and businessmen, including those of James L. Connell, Alfred Hand and F.L. Peck. Even the firm's smaller buildings exhibit an elegance and solidity that still impresses. The Christian Science Building, later the Children's Library, and the old Elk's Club building in the 400 block of North Washington Avenue broaden the range of style and use. The firm's work transformed just about every block in the city of Scranton.

CHAPTER FOUR

IMMIGRANT LIFE FLOURISHES

THEY LEFT THEIR HOMELANDS
AND BROUGHT THEIR CUSTOMS

Immigrants left their homelands in astounding numbers throughout the nineteenth and into the twentieth century. They left for a number of reasons. Farming land was becoming scarce in countries such as Wales and Italy, making it difficult for people to make a living from the soil. The Irish were driven out of their homeland in huge numbers when the potato famine hit. Countries throughout eastern Europe were threatened repeatedly by takeovers from neighboring countries. Jewish people were persecuted in most places at most times. And African Americans came as both free people and as enslaved people who would later become free people. Whatever moved them to leave their homeland, they came to Scranton seeking employment. But the immigrants who came here came to do more than just work. They came to live. And with them, they brought the elements that made a rich and diverse social and cultural climate.

Most immigrants embraced their new home, striving to become Americans. The Victor Alfieri Society was organized on March 11, 1911, to help Italian immigrants find jobs, learn English and generally adjust to their new home.[56] But while all immigrants embraced their new home, they also retained the customs of their old lands, customs that kept them

This March 8, 1935 photograph shows newly elected officers of the Greek Ladies' Society, or *Haravgi*, established in 1917. *Courtesy* Scranton Times-Tribune.

connected to heritage and made Scranton a startlingly diverse city. Eastern European peoples danced the polka and the Irish danced the jig. Italian men played *bocci*, a game played with balls rolled on earthen courts. From Italian kitchens wafted the smell of lasagna and from Greek kitchens the smell of moussaka. Many Catholics prepared baskets of food to be blessed for their Easter meal and carried their statues of saints and other religious articles through the streets in celebration of the feast days of their churches. Jewish

immigrants erected *succas* for Yom Kippur. Places of worship formed the center of community life, and the church picnic or supper was common. Weddings, baptisms (or christenings) and funerals were occasions met with practices brought from home countries. They brought treasures with them, too: a bit of Irish lace or linen to pass down to the next generation; a traditional Italian outfit to dance the *tarantella*; or *pisanki*, eggs covered with elaborate designs common in eastern European countries, to adorn

Reverend William Lesko celebrates midnight mass at St. Mary's Greek Catholic Church, January 7, 1954—Christmas Eve on the Julian calendar. *Courtesy* Scranton Times-Tribune.

an Easter basket. These customs and traditions made up the cultural life of immigrants, and subsequent generations have sustained them. The latter decades of the twentieth century saw new populations of immigrants from India, Latin America and southeast Asia, each contributing their unique cultural elements to Scranton.

They Started Businesses

Many of the immigrants who came to Scranton in great numbers brought specific skills, and the combination of skill and hard work helped build the communities in which they settled. The brewing industry is a good example. Scranton had no fewer than twenty-seven breweries throughout the nineteenth and early twentieth centuries. Some were large, commercial affairs. Others were small establishments whose products served the neighborhood market. Local historian Nicholas Petula has determined that the first brewery established in Scranton was that of German immigrant Philip Robinson in 1854. Mr. Robinson came from a long line of Bavarian brewers and brought his craft with him to Scranton's South Side, where many of the German immigrants settled. He opened his brewery on Cedar Avenue in 1854. At the time, the area was still a small town. In 1860, Philip Robinson was killed in a railroading accident near Moscow, and the business passed into the hands of his three sons—Philip Jr., Jacob and Christian. Sometime during the Civil War, Jacob Robinson started his own business, the Scranton City Brewery, also on Cedar Avenue. Jacob advertised in the city directory as a "maltster and manufacturer of Lager Beer" and a dealer in imported wines.

In 1868, Philip purchased all interests in his family's business and set about expanding it. But his sudden death in September 1879 left a new brewery half constructed on Cedar Avenue. And it left his wife of seventeen years, Mina, with eleven children, the youngest of which was only one year old. With a determination that was common among immigrant men and women, Mina oversaw the brewery's completion, with the help of her brothers. Born Mina Schimpff in Lauterecken, Bavaria, she came to America with her family when she was fourteen years old and married Philip Robinson Jr. when she was just sixteen. After her husband's death, she continued the brewery's expansion, her sons coming onboard as they grew up. Meanwhile, her husband's brother and his wife were running another successful brewing enterprise, E. Robinson's sons. The Robinson family's brewing plants made use of all the latest innovations, boasting the first refrigeration system on the East Coast.[57]

Albert Zenke standing in front of his restaurant in the 300 block of Penn Avenue as it appeared in 1888. It was later moved to 213 Penn Avenue. *Courtesy* Scranton Times-Tribune.

What happens later in Mina Robinson's life is a story that shows the character of the immigrant communities that formed as Scranton grew. She knew that, hard as they labored, it was difficult for her immigrant neighbors to secure funds to build a house or start a business. South Side had no bank of its own at this time, and Mina knew the German-speaking population had nowhere to turn. So she used her financial success to help them. She began to lend money to her friends and neighbors, people who had come to Scranton to make a new life. Eventually, she founded the South Side Bank and Trust Company, with fellow German immigrant and builder Conrad Schroeder as its first president.[58]

They Brought Craftsmanship

Frank Carlucci was born near Naples, Italy, in 1862 and spent the first twenty years of his life there. He came from a family of stone workers and brought that skill with him to America. Carlucci settled first in Syracuse, New York, in 1882, but he moved to Scranton where, for a time, he worked for a railroad before taking a job with Conrad Schroeder, the city's preeminent builder. Carlucci started his own firm, Carlucci & Bro., in 1884 and set up offices on Lackawanna Avenue. The location put the business conveniently near the DL&W Railroad, an ideal situation as the firm transported large quantities of stone. Carlucci & Bro. established its own quarries in Nicholson and Forest City. Whether with Schroeder or as the senior member of his own firm, Carlucci did some of the most impressive stonework in the city, including that of the Hotel Jermyn, Elm Park Methodist Church and Traders Bank. Frank Carlucci gave to his community in other ways. He organized the first Italian-language newspaper in this part of the state, the *Pensiero*, and belonged to many organizations, including the Lackawanna Chapter of the Mason's Union Lodge. But a crowning achievement in his illustrious career as a master stone worker is the Columbus Monument on Courthouse Square. Carlucci conceived the idea to erect such a monument, formed a committee and took the position as its president. And, of course, he undertook the job of making the stone statue. Italian citizens gave contributions for the monument in honor of their countryman, Christopher Columbus. On October 21, 1892—in honor of the 400th anniversary of the day Columbus landed in the Americas—the statue was unveiled on the northwest corner of Courthouse Square, where it has remained as a testament to the contributions of Italians who left their homeland and settled in America.[59]

They Brought Music

The Welsh were among the first immigrants to settle in Scranton, bringing their skills in mining and iron manufacturing to the Lackawanna Iron & Coal

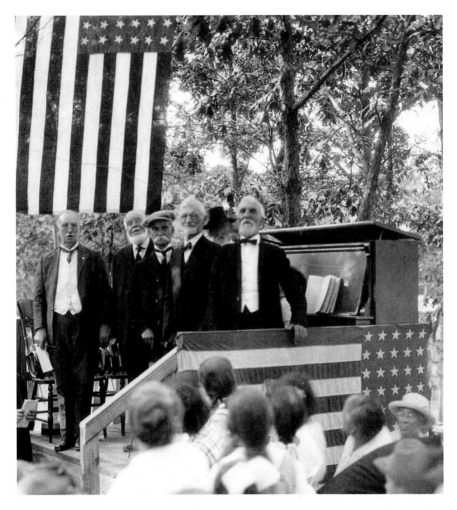

Rocky Glen Amusement Park was a popular attraction. This August 21, 1921 photograph was taken during Welsh Day at the park. *Courtesy Lackawanna Historical Society.*

Company. These men and women were part of a wave of Welsh immigration that began as a result of poor harvests and an increase in population in Wales. As early as the 1830s, the coal fields in Carbondale drew them. Among the Welsh, the Eisteddfod was a cultural institution that, in Wales, was "for ages the nursery of poetry and song, the home of her folklore and a most important educator in the sciences, the arts, literature, oratory, classical music (which was its dominating feature) and industrial handicraft, particularly needle and knitting work by the women. All of these were promoted and stimulated by

rivalry and competition."[60] Eisteddfods were popular on the local, national and international scene, and in Scranton, the Eisteddfod emphasized music. Scranton's Welsh singers enjoyed great success. An Eisteddfod was held in 1875 in a large tent, known as Gilmore's tent, at the corner of Price Street and Sumner Avenue on Scranton's West Side, where many people of Welsh descent had settled. Three choirs participated, one from Hyde Park and two from Plymouth. So closely were they matched that a second singing was required by the judges to determine the winner. A large choir, under the leadership of Mr. Robert J. James, won the first prize after a most exciting contest. Local singers traveled to competitions in cities such as Philadelphia and Pittsburgh.

In 1893, a great Eisteddfod was held in Chicago at the Columbian Centennial Exposition. The Cymrodorian Society of Hyde Park, under Dan Prothroe, and the Scranton Choral Union,[61] under Hayden Evans, competed at that Eisteddfod against the Salt Lake City, or Mormon, Choir, led by Mr. Evan Stevens, and the Western Reserve Choir of Ohio, under Jenkin Powell Jones. The Scranton Choral Union won the competition. On their return home, they were greeted by thirty thousand people who flocked to the railroad station and lined the route to greet the victors.[62]

THEY BROUGHT RELIGION

They came from diverse parts of the world, many torn by war and crippled by poverty. Their language, their clothing and their customs all reflected the heritage they brought with them. None would be more lasting than religion. In their broadest categories, they were Protestant, Catholic, Orthodox and Jewish. But upon close examination, the broad cloth that made up the fabric of Scranton's religious life contained many threads. The early industrialists were Presbyterian and Episcopalian. Methodists, Baptists and others arrived early, too. The Catholic Church broke down, as it did in Europe, into the Roman Catholic Church and the Eastern Catholic Church. Immigrants who practiced the Roman Catholic faith included Irish, Italians, Lithuanians and Polish. Ukranians, Hungarians,

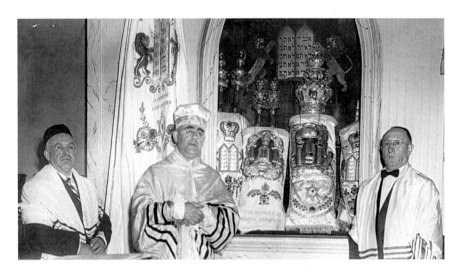

This photograph shows participants in the Yom Kippur service at the Linden Street Temple on September 28, 1952. *Courtesy* Scranton Times-Tribune.

Lebanese and others belonged to the Eastern Catholic Church, whose rites included Greek, Melkite and Maronite, among others. Orthodox churches included Russian, Greek and Ukrainian. Jewish immigrants followed Orthodox, Reform and Hasidic traditions.

But some interesting changes took place in their new home. A look at one religious movement illustrates this point. Approximately 2.5 million Polish people came to America between 1850 and 1914, and more of them came to Pennsylvania than to any other state. The vast majority of Polish immigrants belonged to the Roman Catholic Church, and they built new churches wherever they settled, often with their own resources and their own hands. Their lives were closely tied to their churches, and many of them wanted Polish priests and masses conducted in the Polish language. These expectations did not sit well with the Catholic Church, and a separatist movement arose, not only in Scranton but also nationally. In 1897, tensions came to a crisis point when Reverend Francis Hodur organized, on March 14, an independent church, St. Stanislaus Bishop & Martyr, in Scranton. On March 2, Father Hodur celebrated the first mass at this church and also announced his "Kosciol Narodowy" (National Church) program. That program called for the parish to have legal ownership of its properties, to govern itself in secular matters, to appoint priests approved by parishioners and to appoint Polish bishops

in America. The Roman Catholic Church excommunicated Father Hodur the following year. In September 1904, his parish, along with twenty-four others from across the country, formed the Polish National Catholic Church. It continued to grow well into the twentieth century. The majority of Polish immigrants remained within the Roman Catholic Church, but the separatist movement opened itself to the advancement of Polish clergy.[63]

THEY FOUND FREEDOM

Some of the people who came to Scranton had a unique history that began in southern slavery. Not much is known about Scranton's role during the years when the Underground Railroad saw thousands of enslaved people move north to freedom, but surviving accounts do say that numbers of them passed through the Providence section of the city. Most went farther north to settle in Montrose, New York State, or points even farther north— farther away from slaveholding states. One of those was Mary Jane Merritt. Her family had escaped slavery into Canada, but they returned to settle in Waverly, where a community of free blacks existed as early as the 1840s. There, Mary Jane worked as a servant until she moved to Scranton. The 1870–71 Scranton City Directory lists Henry Merritt residing on Wyoming Avenue near Hickory Street. By 1873, Mary Jane is listed as Henry's widow, residing "on the hill opposite the L&S railroad depot." By 1876, the directory shows her residing at Center Street near Penn Avenue. The Merritts had several children. Mary Jane established herself as a merchant. Her husband Henry had worked as a grocer. The 1880 city directory lists her as the proprietor of general merchandise on Wyoming Avenue, and the 1881 directory contains an advertisement identifying her as a "dealer in dry goods, groceries and provisions, Wyoming Avenue (Scranton Flats)."

Meanwhile, the Merritts had no church. The American Methodist Episcopal Church was a vital part of community life for both free black people and those escaping slavery. The AME Church existed in Waverly in 1844 with the Reverend James Hyatt as pastor. Not finding such a church

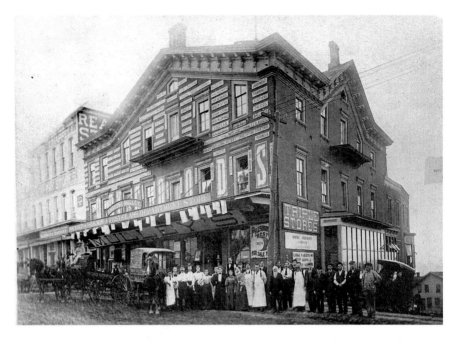

Mulley's store, covered in signs advertising its wares, including cheese and spices, baled hay, brooms and carpets, silk and flannel. *Courtesy Lackawanna Historical Society.*

in Scranton, it seems that Mrs. Merritt opened her home to other African Americans who wished to establish a church. This was about 1870. It is uncertain at which residence her group met, but they soon moved their meeting place to rooms above the Boston Store on Lackawanna Avenue, a fact that suggests the congregation might have been growing. As it grew, the church had several homes in buildings throughout the city. In 1912, the Bethel AME congregation built the church on North Washington Avenue. In 1927, they sold their original church building on Howard Place to the Scranton School Board for $16,000.[64] From her life as a slave in the South, Mary Jane Merritt found in Scranton the freedom to form a new church, raise a family and establish her own business.

They Found Opportunity

Patrick W. Costello was the only son of William and Bridget Langan Costello, who came from County Mayo, Ireland. Patrick was born in the Minooka section of Scranton in 1866, the year of the city's incorporation. William Costello was a coal miner, and Bridget Costello died when Patrick was very young. About 1871, William went to Birmingham, England, to find work, taking his five-year-old son with him. They returned in 1877, and Patrick got a job picking coal at the Bellevue Coal Breaker. When he was about thirteen, he left mining work behind him and took a job as a clerk in Millett's neighborhood grocery store in Bellevue. All this time, though, young Patrick was harboring a talent. He had been exposed to pen and ink in Birmingham, and although there is no evidence to suggest he ever had any formal training, Patrick loved to work with pen and ink. Costello had a varied career that included politics and the restaurant business, but his pen and ink work catalogued the region's development. During the nineteenth century, resolutions were popular. The often large and elaborate documents marked notable occasions, and many of the finest were Costello's work.

"Engrossing" means to add beauty to written letters, and Costello perfected the art, rising to one of the best in the country. At the 1899 retirement of William Hallstead, general manager of the DL&W Railroad, the Brotherhood of Locomotive Engineers presented him with an exquisitely engrossed resolution. The centerpiece was an intricate drawing of a locomotive named the W.F. Hallstead. Civil War hero Colonel Ezra Ripple dedicated his memoir *Dancing Along the Deadline* to his good friends, Mr. and Mrs. William Connell. Costello crafted a dedication page with portraits of the Connells intertwined with an American flag, among other mementos of the war. Given his history in the mines, it is fitting that Costello would be chosen to do a resolution for local miners' hero John Mitchell, presented by young Bennie Phillips. "I represent the Breaker Boys of the Anthracite Region," the resolution reads, "and have been selected by them to present President Mitchell...a token of our respect and love for him." The resolution is dated October 27, 1900. When Dr. Isaiah Everhart gave a museum to the city of Scranton, the city presented him with a resolution, done by P.W. Costello, at the May 30, 1908 ceremony. The work of this breaker boy turned artist literally illustrated Scranton's development.[65]

CARING FOR YOUR NEIGHBOR

A CITY IN NEED

The citizens of Scranton stepped up to the duty of caring for their neighbors in impressive ways. Young women, many of them mere girls, left their homes and came to the city to work. The coal mines, railroads and other heavy industries killed men, leaving widows and children behind, many with no family to help them. These same industries maimed workers, leaving young families with scant means—or no means—of earning a living. The vices of the day—liquor, pool halls and prostitution—tempted many a young man. The sick and infirm of all socioeconomic levels needed care. A wide range of social and charitable organizations developed to meet the spiritual and material needs of the people. They included, among others, House of the Good Shepherd, St. Joseph's Foundling Home and the Jewish Home for the Friendless. Hospitals of all types were opened, including the West Mountain Sanatorium, which treated tuberculosis cases. It would require many pages to detail each and every way in which Scrantonians helped their neighbors, but a look at a few organizations illustrates the extent to which this community cared for its own.

YMCA AND YWCA

The Young Men's Christian Association (YMCA) organized in a little room above the Neptune Fire Company in 1858 for the benefit of the boys, young men and young women of Scranton. John Brisbin, general counsel for the Lackawanna Railroad, was its first president. Colonel Hitchcock wrote that he could "well remember the coarse little pine table, home made, at which the president sat, and the plain wood benches, also home made, on which we sat, some twenty of us." The YMCA was concerned with promoting Christian values. One of its first projects was to launch an attack on the Sunday sale of liquor, a violation of both the local law and the moral sensibilities of many of the citizens. Like other organizations, it suffered during the Civil War while many were away. It reorganized in 1868 with Alfred Hand as president and opened its rooms to those who came new to the city and required temporary shelter. In the early years of the twentieth century, the YMCA expanded its programs for boys and paid special attention to the needs of "foreigners"—the immigrants who were moving into the city in large numbers.

On October 23, 1880, a group of YMCA members met at the home of Alfred Hand. Its purpose was to establish, within the organization, a Railroad Department to tend to the needs of those whose railroad jobs brought them into the city on a regular basis. Many of the boardinghouses were known for the drunken and disreputable behavior of some of the clientele. The Railroad Department purchased a building where railroad workers could get a clean bed in a safe environment for ten cents per night. It provided religious services for the railroad men and visited the sick among them.

Although the by-laws of the YMCA stated that the organization was to help young women, that part of its role had been neglected. So the Young Women's Christian Association was organized in May 1888, with quarters at 312 North Washington Avenue. The YWCA paid special attention to serving the needs of young women coming into the area in search of work. For them, boardinghouses were an even less desirable option than they were for the men. The YWCA offered a "place to meet a friend, write a letter, or

linger in an attractive library between engagements. A place to get a well cooked meal and have it quickly served…A place to gain new courage and inspiration from a Bible class. A place to attend entertainments, or have a happy, healthy time at parties. A place to find a helping hand when you need it most."[66]

HOME FOR FRIENDLESS WOMEN AND CHILDREN

One night in 1871, Mr. C.R. Mossman found a sick woman on the streets of Scranton in need of protection and care. This was an era without government welfare programs of any kind. Those in need relied on the goodwill of family and neighbors to help them. But for the city's poor, help was often difficult to come by. Women whose husbands had died or were incapacitated, and who were unable to support themselves, had few options. If they had young children, fell ill or lost a job for some reason, they often had no one to look after them. Such women were indeed friendless.

Moved to establish a permanent means of helping this woman and others like her, Mr. Mossman enlisted the help of several prominent citizens. A group of women met at the YMCA on September 27, 1871. They elected a board of directors, and the Society of the Home for the Friendless Women and Children of the City of Scranton was born. Anyone could become a member of this organization. Annual dues were three dollars. At an October 6 meeting, fifty women became members, three of them for life through the payment of fifty dollars each. With money provided by the poor directors, they leased an eight-room house at the corner of Franklin Avenue and Linden Street and partially furnished it. Seven women and nine children were admitted to the home. The next year, the Lackawanna Iron & Coal Company donated a lot on Adams Avenue, where Scranton Technical High School would later stand. The society built a new home and gave up the residence on Franklin Avenue.

In 1874, Mrs. H.F. Warren, recording secretary, wrote of the Home for Friendless Women and Children: "At present there are fifteen inmates, all of whom are cases which appeal strongly to our sympathies—one an old woman

whose sands of life are nearly run, and who after a life of toil, longs to enter upon her eternal rest." There was also "a friendless German girl who came to us sick, miserable and helpless, with the story of her life written upon her sallow forbidding face, but who under the influence of care, kindness and comfort, has brightened into cheerfulness." That same year in the house lived three motherless children whose invalid father, after struggling to provide for them, reluctantly gave over their care to the society. There was also "one bright little boy of two years, fatherless and motherless, for whom there beats no heart on this broad earth," as Mrs. Warren described him. The organization conducted fundraising events to keep the home in operation.[67] Later, the organization would continue to serve the community as Friendship House, carrying on the good work inspired so long ago by one woman found alone and in need on the streets of Scranton.

Scranton State School for the Deaf

A class of eight children met for regular instruction in a room in Scranton in 1882. They and their teacher, Jacob M. Koehler (who later became Reverend Koehler), were deaf. The class was the first of its kind in northeastern Pennsylvania. To expand the school, the citizens of Scranton provided financial and other assistance. They hired Miss Emma Garrett, an 1878 graduate of the Boston University School of Oratory, where she had followed Alexander Graham Bell's course for teachers. At the time, two methods of teaching were in use. One relied on sign language. The other was known as the Oral Method, a method of speech and lip reading that Miss Garrett favored. The Scranton State School for the Deaf opened as a day school with twelve pupils on September 10, 1883, in the chapel of the German Methodist Church. A committee looked after its needs and provided for its support. That committee included some of the most notable citizens in Scranton: Henry Belin, L.A. Watres, Samuel Logan, William Connell, John Jermyn, William T. Smith and E.B. Sturges. The school was supported in part by private subscriptions. Within a few years, it became apparent that a boarding school was needed. In the fall of 1883, the search began for a

building site. Five acres of land were secured from the Pennsylvania Coal Company, and an additional five more acres were acquired. By 1884, Mr. Watres began to look to the state for patronage. John T. Williams had been elected to the state legislature in the fall of 1884. During his second term in office, he was able to get a bill for financial support of the school through both houses. Governor Beaver signed the bill into law. Miss Garrett served as principal of the school from 1884 until 1891. Reverend Koehler remained a leading advocate of compulsory education of the deaf.[68]

HAHNEMANN HOSPITAL

As the city of Scranton grew, a number of hospitals opened to meet the needs of the community. The Lackawanna Hospital opened at the Episcopal Church property on Penn Avenue. Later, the Scranton State Hospital opened in 1872. Moses Taylor opened in 1892. The West Side Hospital opened in 1896. Mercy Hospital opened in 1925.

But one of the truly remarkable stories of the age is the organization and opening of Hahnemann Hospital. In this era, women of the laboring classes worked just as hard as men, at home, in the silk or lace industries or in family-run businesses. Women of the upper classes did not, as a rule, work in the same way. Instead, they used their social roles to alleviate the suffering of this industrialized valley. One of the most astounding achievements of the women of this social class was the establishment of Hahnemann Hospital in 1897.

The year that Hahnemann Hospital was established, newspaper headlines recorded all manner of illness and accidents. The city experienced outbreaks of measles and diphtheria. A fire broke out in the Pettibone mine. There were shootings and stabbings. A child fell into a vat at a packinghouse and was scalded. Miners suffered gas burns at the Bellevue mine. One person's leg was crushed and another's severed in two separate train accidents. There was an explosion at a building on Pittston Avenue and a mine strike that led police to shoot at and kill twenty-one men and injure forty others. Mrs. J.W. Oakford, Mrs. Thomas Dickson and others must have seen these headlines

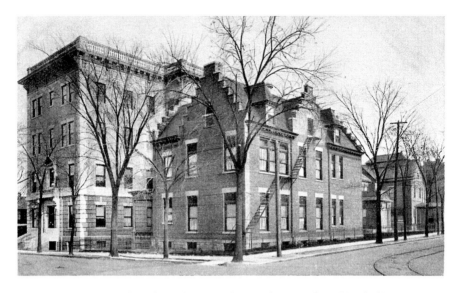

The Lackawanna Hospital, pictured in 1872, became Scranton State Hospital in 1901. *Courtesy* Scranton Times-Tribune.

and realized that a new hospital was needed. With these women as officers, the hospital opened its doors at the former James Blair home at 433 Mulberry Street, at the corner of North Washington Avenue. The women remained on its board and oversaw its day-to-day operations. Mrs. H.M. Boies served as president and Miss Minnie Yardley as superintendent. They had a female doctor on staff, too—Dr. Anna C. Clark, trained in homeopathic medicine and practicing in the city. The business of running a hospital included fundraising and expansion. In 1904, the hospital occupied a residence at the corner of Monroe and Linden Streets. In 1905, ground was broken for a new hospital on Colfax Avenue. This was an era of progress, and the hospital was committed to bringing the most up-to-date care to its patients. Hahnemann provided care for the sick and suffering of all classes. The staff treated, at no charge, those who could not afford to pay.[69] It is impossible to know just how many lives were touched by the good ladies and the staff they managed, but their work deserves to be remembered.

Young Men's Hebrew Association

On Sunday, September 12, 1909, a group of about ten enthusiastic people met in a building on the 300 block of Lackawanna Avenue. About fifteen others came, eager to find out the meeting's purpose. This was the beginning of the Young Men's Hebrew Association (YMHA). Abraham Friedman was elected president. They felt "called upon," according to Colonel Hitchcock, "to perform the mission of raising the standard of the Jewish young men and women of this community to a higher plane, spiritually, physically, mentally and morally." The organization offered young men and women a place to meet. It held business and literary meetings, social affairs and various forms of entertainment. The YMHA gave young men "an opportunity to come in from off the streets, away from the pool rooms, the street corners and the saloons and other evil environments into a place where they [could] become better Jews and better citizens." In 1911, a ladies' auxiliary was added to the

Charles Jenkins, with his mother, was the recipient of an electric reading machine for the blind, which played a recording of someone reading a book. *Courtesy* Scranton Times-Tribune.

association. In 1913, David Landau was reelected president, and under his second administration the literary meetings, under the direction of Sandy Weisberger, grew crowds too big for the meeting rooms to hold. Early in 1914, a building campaign began and raised $53,000 with which to buy a new facility. On Sunday, March 22, 1914, the YMHA moved into its new home at 440 Wyoming Avenue.[70] In 1949, the organization became the Jewish Community Center of Scranton, a name it carried into the twenty-first century.

LABOR AND INDUSTRY IN THE TWENTIETH CENTURY

LABOR STRIFE AND REFORM

The nineteenth century was a boom era for Scranton. That boom brought industry and commerce, innovations, prosperity and culture. But for thousands it also brought the social ills of poverty, child labor and unsafe working conditions. The twentieth century inherited those problems, but it also brought with it a turning point that would lead to unprecedented reforms in labor practices. The fight for labor reform had been part of the nation's industrial history. Periods of economic depression, such as those that occurred in the 1870s, were peak periods of labor strife as low-paid workers endured further cuts in their wages.[71] Low wages were only one of the complaints among area coal miners. Dangerous working conditions were another. Fires, cave-ins, explosions, falls, accidents with cars or equipment—these were regular occurrences in the mines and breakers throughout coal country. They resulted in loss of lives, loss of limbs, burns and other serious or minor injuries. These injuries often put a man out of work. Low wages or lost jobs contributed to yet another issue: child labor. Coal breakers employed boys as young as seven years old. Boys worked as doormen in the mines. Girls worked in silk mills and other "needle trades."

Workers attempted to unionize, but again and again coal barons refused to recognize the unions. The United Mine Workers of America, a national

organization, formed in 1890, but the problems persisted. John Mitchell, an Illinois native who had worked as a bituminous coal miner, became president of the UMWA in 1898. Charismatic and enthusiastic, he was greatly loved by the anthracite coal miners. Still, the coal barons refused to recognize his union.

The labor situation was about to take a significant turn, however. In October 1902, anthracite coal miners in northeastern Pennsylvania were in their fifth month of a strike. The approaching winter had President Theodore Roosevelt concerned about the nation's coal supply. The captains of industry were united in their thinking: the federal government had no Constitutional right to interfere with relations between owners and laborers. Roosevelt's position was that the government represented the people—the common good—and that this fact had to be of greater concern than the demands of either the captains of industry or the labor union. Roosevelt wanted those coal mines back in operation, so he sent telegrams to Mitchell and to several principal mine owners, requesting that they meet with him in Washington on Friday, October 3. Among those in attendance was George Baer, an independent owner who, when confronted with the issue of suffering miners, is said to have commented, "Suffer? Why they don't suffer. They don't even speak English." William Truesdale, president of the Delaware & Hudson, was present at that meeting, as was Thomas Fowler of the New York, Ontario & Western and others. After the meeting, Roosevelt ordered a Strike Commission be put together to hear the positions of both the mine workers and the mine owners.

On November 14, 1902, the Anthracite Coal Strike Commission hearings opened at the Lackawanna County Court House with attorney Clarence Darrow representing the United Mine Workers of America. Darrow called John Mitchell as the first witness. In all, Darrow called more than two hundred witnesses, including coal miners and breaker boys, who attested to each and every aspect of the degradation and misery of the coal miner's life. But Darrow widened the picture even further by calling several young girls—silk millworkers—to the stand. The silk industry moved into the Lackawanna Valley to take advantage of cheap labor in the form of coal miners' wives and daughters, women and girls who went to work to supplement inadequate incomes. The testimony of one thirteen-year-old Dunmore girl, Annie, shows the difficult conditions and dangerous circumstances that so many young girls found themselves in. Annie told the commission that she walked half an hour to get to work for the start of her 6:30 p.m. shift, worked until 6:30 a.m. and then walked half an hour to get home. Annie was employed as

Pallbearers carry John Mitchell's casket from St. Peter's Cathedral in Scranton following the funeral mass on September 12, 1919. *Courtesy* Scranton Times-Tribune.

Father John Curran gives the final blessing for labor leader John Mitchell at Scranton's Cathedral Cemetery. *Courtesy* Scranton Times-Tribune.

a twister, which meant that she was responsible for watching the machinery that took silk threads from their reels, brought them together and twisted them into yarn and then wound them onto spools. She had to keep alert for broken strands of silk and remove the full spools from the machine when the process was complete. For the whole of her shift, Annie had to stand. Like most other girls in this industry, she was allowed a half-hour break for a meal. She earned five and a half cents per hour.[72]

The UMWA concluded its presentation to the commission on December 17, 1902, and a holiday recess was called until January 9, 1903, at which time the hearings resumed in Philadelphia. On February 15, Darrow delivered his summation. On March 18, the commission presented its report to President Roosevelt, who made it public on March 21. The commission recommended the following: a 10 percent wage increase, a nine-hour work day (eight for a few specific jobs) and a fairer means of weighing coal.[73] The commission did not call for recognition of the union, saying that the issue was out of its jurisdiction. But it did create a permanent six-member board of reconciliation to hear grievances, an accomplishment that pleased Mitchell greatly.[74] The hearing did not solve all of the labor issues among coal miners. But it was a turning point. And it was also a historically significant event in that it marked the first time the federal government interceded in a dispute between labor and owners.[75]

The Changing Industrial Climate

The year of the strike brought another big event to Scranton. This is the year when the Lackawanna Iron & Coal Company—the industry that had made Scranton—left and moved its operations to Buffalo, New York. Hitchcock writes:

> *There has never been an adequate explanation of its going. It had one of the largest and best equipped plants in the country, in active prosperous operation, with a capacity of 150,000 tons of pig iron; and—with its two mills—of a half million tons of steel rails per year. The invested*

value of its plant was upwards of $6,000,000. It was in all respects up to date in its machinery and equipment. Its producing capacity being second in the list of steel plants in the whole country. There was no dearth of orders, and prices were fairly profitable...They deliberately butchered in cold blood, a magnificent six million dollar plant!! This is not all; apparently madness knew no limits; they dismantled and freighted two hundred and sixty miles to Buffalo, and threw into the junk pile, machinery that was actually earning for them yearly almost its weight in gold![76]

The loss was a blow to the city, but its industrial life was still solid. The curriculum of the public high schools reflected that. The population was growing at such a rate that Scranton Central High School—the city's only high school—was soon unable to accommodate all the students who wished to attend. With the situation at a crisis, Mrs. W.T. Smith offered to build a manual training school for boys in honor of her late husband, who had been an industrialist. The city accepted her offer. Meanwhile, plans to erect an additional high school moved ahead, and in 1905, the high school's Commercial Department moved from Scranton Central High School to the new Scranton Technical High School. The W.T. Smith Manual Training School and Scranton Technical High School stood side by side, joined by a bridge. They opened the same year, and they worked as a single school.

The Manual Training Course for boys included the usual English, history and various mathematics courses. In addition, boys learned mechanical and shop drawing, pattern making and forging and foundry work. The school's Industrial Course included vice and machine tool practice, preparing boys to operate complex industrial machinery. Girls in the Manual Training Course studied the usual academic subjects. They also learned how to build and tend a household fire, make beds and remove stains from clothing. Cooking classes taught them how to cook for invalids and children. The girls studied bacteria and learned to preserve and can foods. They learned to make all their own garments, as well as to make and trim their own hats. Drawing courses taught them to design both useful and ornamental articles for the home, and applied arts courses allowed them to make some of those articles. Girls learned embroidery and Irish crochet work, leather tooling, metalwork, weaving and rug making. The Commercial Course at Technical High School prepared both boys and girls in bookkeeping, stenography and typewriting. Penmanship, commercial arithmetic and correspondence were also taught.[77]

Some industries continued to expand into the twentieth century. By 1910, there were twenty-three silk mills in the city. In the early 1900s, Pennsylvania silk mills accounted for about one-third of the silk manufactured in the United States. This industry relied primarily on girls and young women, and the Scranton area had a great number of those. Yet wages for silk workers in Scranton were lower than they were in other areas. Spinners who worked in Patterson, New Jersey mills earned about $5.50 per week in the first decade of the twentieth century, while Scranton workers averaged $3.00 per week for the same job. Patterson employees worked fifty-five hours per week, while Scranton workers put in fifty-eight hours. Following a strike in 1907, the hours in the Scranton mills were reduced to fifty-five per week. A wage hike in 1913 brought their income to $4.40 per week. When the United States entered the First World War, the silk industry added a new item to its manufacturing itinerary: parachutes. World War II would see the advent of synthetic fibers for parachutes and other uses, but silk parachutes were still in use during this war, and Scranton's mills supplied them.

In 1913, the Scranton Board of Trade launched the Scranton Plan, establishing a $100,000 fund to assist new industries to the city. The following year, with Ralph Weeks as president, the BOT began the Million Dollar Investment Fund. More than five thousand people bought shares in this corporation, raising over $1 million in eight days. Industries that came to Scranton included the Maccar Truck Company, the Adelphia Shoe Company, the United Ribbon Company, the National Carbon Company and many others.[78] Local industries continued in the spirit of innovation that had made Scranton.

On January 22, 1914, a Delaware, Lackawanna & Western train sent a historic transmission to the *New York Times* using a Marconi wireless telegraph system. The special train, traveling at a rate of more than sixty miles per hour, carried five hundred members of the American Society of Civil Engineers from Hoboken, New Jersey, to Nicholson, Pennsylvania, and back. Shortly after the first message was received, Hunter MacDonald, president of the engineer society and chief engineer of the Nashville, Chattanooga & St. Louis, sent a second message. More than thirty wireless messages were sent and received by the Marconi operator on the train that historic day.[79] The new system would revolutionize the railroad industry, allowing companies to direct trains quickly and safely.

By 1915, the city's population had reached its peak at 150,000, and Scranton manufactured more than seventy different articles with a total value

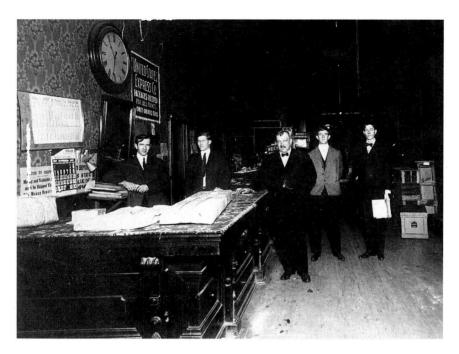

Pictured in this circa 1907 photograph, the office of the United States Express Company offered one means of sending parcels or freight. *Courtesy* Scranton Times-Tribune.

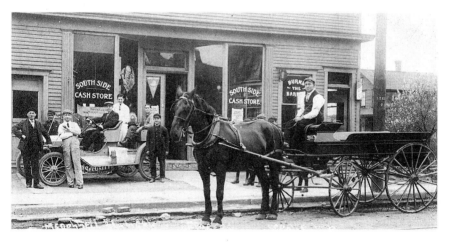

An early automobile next to a horse-drawn carriage outside the South Side Cash Store emphasizes the transitional nature of this era. *Courtesy* Scranton Times-Tribune.

of approximately $100 million. They included typewriters and glassware, furniture and pianos, lace curtains, woolen underwear, paper boxes, silk fabrics and axles and other parts for automobiles. City manufacturing firms supplied the railroad, mining and other industries with all manner of items, including railroad cars and locomotives, stationary engines, hydraulic machinery and mining machinery and supplies.

THE ROARING TWENTIES AND PROHIBITION

The Roaring Twenties brought another new innovation to Scranton: radio. On October 1, 1922, Scranton mayor John Durkin, fellow dignitaries and a host of local entertainers gathered at WLAO. Excitement must have filled the air as the group anticipated the first broadcast of the city's first radio station. But the occasion proved to be less than auspicious. Something went wrong with the equipment, and patient listeners heard nothing more than a hum. Adolph Oschmann helped repair the failed equipment. The station finally filled the airwaves a few days later. "We were licensed for 100 watts" of power, Mr. Oschmann had explained, "but we never used more than 10." WLAO lasted only a few months, but station WRAY, owned and operated by John Harvard "Casey" Jones, took over in the same building. Casey Jones was, by all accounts, one of the era's fabulous characters. He had worked as a minor entertainer on Broadway, married a chorus girl and moved to Scranton. He wore pince-nez (those little glasses that perch right on the nose), played his show biz character to the hilt and acted the perfect darb, as a colorful character was known in those days.

Radio truly was an experimental endeavor. WRAY's transmission tower stood atop an adjacent building at the corner of Spruce Street and Franklin Avenue. Six guy wires supported it. They were attached to chimneys on the roof. "There'd be heck to pay after a windstorm," Mr. Oschmann recalled forty years later. "The guy wires would collapse and pull the chimneys down with them." And passing streetcars drowned out programs with static.

WRAY folded in 1924. Prior to that, Mr. Jones had made an arrangement with the *Scranton Times* to use his studios for its news broadcasts. The

The first sack of mail to be sent by air is handed to a pilot at the Clarks Summit Airport in 1919. *Courtesy* Scranton Times-Tribune.

first of these aired on November 29, 1922. In time, the newspaper got its own call letters, WQAN, and Oschmann went to work for it. The Voice of Anthracite would be a radio staple with listeners throughout the Lackawanna Valley.[80]

Music-related technology found its way to Scranton in another interesting way. Buttons made by the Scranton Button Company were pressed from a shellac-based material, and in the 1920s, the Scranton Button Company started pressing shellac gramophone records. By the early 1920s, it offered full-service record production to any retailer that desired its own label. The industry continued to grow. In August 1922, the Emerson Phonograph Company reorganized, and the Scranton Button Company bought the Regal Record Company from it, a move that made it into a full-service production company. In July 1929, the Scranton Button Company merged

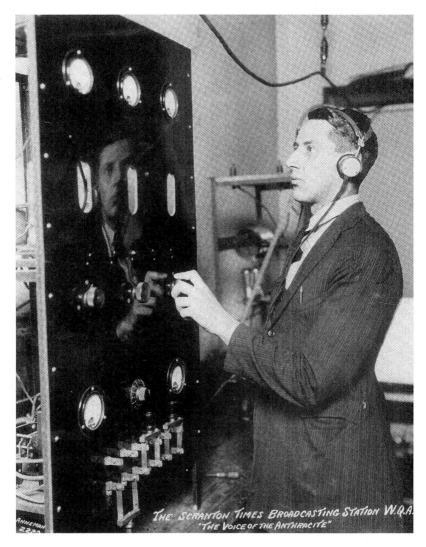

Adolph Oschmann at the controls at station WQAN, the Voice of Anthracite. *Courtesy* Scranton Times-Tribune.

with the Cameo Record Corporation and the Regal Record Company to form the American Record Corporation.[81]

With all these modern innovations, some older practices hung on. In 1922, for example, ice was still used in home refrigerators and industries. Modern inventions that made ice brought a decline for harvested ice, but World War II brought a slight increase in the demand as industries all around

the country devoted themselves to the war effort. Locally, ice harvesting continued into the next decade. In 1950, three hundred men assembled to cut ice at three ponds in the Gouldsboro and Tobyhanna area. That year, a total of 120,000 tons of ice was cut. In 1951, officials at the West End Ice Company in Gouldsboro and at the Tobyhanna Creek Ice Company reported ice thickness of ten to twelve inches. That year, between 50,000 and 75,000 tons of ice was cut. The decrease in production was due to the declining market for naturally harvested ice.[82]

The 1920s roared, but they also brought Prohibition, and the city's vast beer industry suffered. In 1897, many of the bigger breweries had aligned themselves under the name Pennsylvania Central Brewing Company. But Prohibition hit hard. Some of the companies, such as M. Robinson's Sons, sold tonics and soda water. Manufacturers of tonics advertised their healing powers for a range of ills that included nervous conditions, indigestion and listlessness, and their bottles prescribed dosages. In reality, many of them had a fairly high percentage of alcohol, making them a desirable commodity during the country's dry spell. Many of the smaller beer manufacturers did not survive Prohibition, but others made it through with these alternative products.[83]

THE GREAT DEPRESSION AND WORLD WAR II

The Great Depression hit Scranton's industries just as hard as it hit those in any other American cities. The Depression combined with other factors to undermine Scranton's two leading industries. The use of anthracite coal as a fuel was in decline as gas and oil were on the rise. The automobile began to take its place in the American life, and fewer people relied on passenger train service. Trucking cut seriously into the railroad's freight business. Difficult economic times and a changing market would ensure that the city's two largest industries—coal and railroading—would never again see the prosperity they once knew. But other industries survived, as did business and commerce.

The workers of Scranton suffered. But the spirit of charity that had followed Scranton through its development remained with it still. From

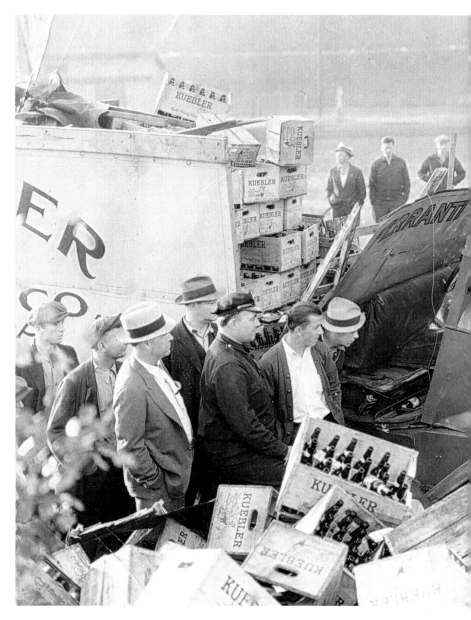

A delivery truck carrying Kuebler Beer collided with an Ontario & Western Train, circa 1936. *Courtesy* Scranton Times-Tribune.

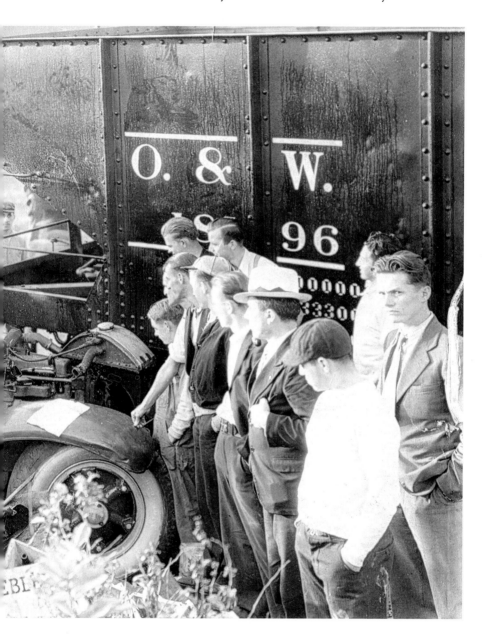

Above: Works Progress Administration teachers of the blind with their seeing eye dogs. *Courtesy* Scranton Times-Tribune.

Left: Pictured here in 1933 are Anna Rusnak, Wilma Andrake and Agnes Rusnak, the author's grandmother. All three ladies worked "in town." *Courtesy the author*.

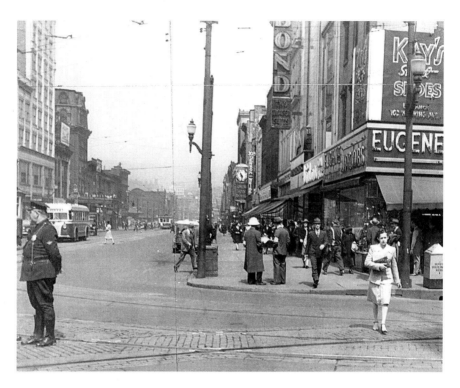

Busses had begun to compete with electric trolleys. On the corner is Eugene Jacobs, a well-known Scranton clothing store. *Courtesy* Scranton Times-Tribune.

its beginning, Hahnemann's purpose was to provide care for the sick and suffering of all classes. The staff treated, at no charge, those who could not afford to pay. During the Depression, 70 percent of the care given at the hospital was provided free of charge.[84]

Despite hard times, Scranton had a solid core of working-class and professional people who maintained comfortable lifestyles.

World War II left the country's industries short on manpower. In 1943, Scranton took advantage of that situation and welcomed the Murray Corporation of America to town. Organized in June 1926, the company built airplane parts crucial to the war effort. Early in 1943, it had plenty of space in its Detroit facility but a shortage of workers. Indeed, Scranton did send many of its men to war. Two Lackawanna County residents—Private First Class Gino J. Merli and Second Lieutenant Joseph R. Sarnoski—received the Medal of Honor for their heroic service.[85] But the city had plenty of people ready to work. Construction moved at a wartime pace. Members of

the Murray Corp., along with U.S. Army Air Forces representatives, chose the site: the location of the former Lackawanna Iron & Steel Company's South Works. Excavating began on June 15, 1943. More than seven hundred men worked ten-hour shifts. Floodlights were installed for the night shift. Explosives were needed to unearth the huge masses of slag that were remnants of the old ironworks and steelworks. Meanwhile, training got underway on May 28, 1943, at the former National Youth Administration shops on Wyoming Avenue in Scranton. By October, production began in certain areas of the plant while construction continued. The new factory was rushed to completion in five months, at a cost of $6.5 million.

"We are proud of Murray Corporation's place in the war program," said company president Clarence W. Avery in 1944. The nation was fortunate to have this kind of innovation at this critical time in world history, and Scranton was fortunate to have the Murray. On February 28, 1944, the plant went on a 'round-the-clock production schedule. The Scranton plant manufactured wings for bomber planes and other parts. In a period of thirty consecutive days, it delivered seventy-eight main condensers for Liberty ships. Combined with the company's other work, this set a record unsurpassed in the nation. More than 2,000 workers were on the payroll by April, and the area looked forward to more than $10 million in wages and salaries from this new enterprise. After the war, the Murray continued to be a strong presence here. In 1948, it acquired the Eljer Plumbing Company, and the plant produced a variety of enameled fixtures for bathrooms and kitchens. From 1955 to 1963, it produced washers and dryers for the Easy Appliance Division. Through the late 1960s it employed 8,700 people locally and ranked 369th among the country's largest corporations.[86]

A CITY AT LEISURE

ELECTRIC TROLLEYS

The trolley ushered in a new era in Scranton's history and helped earn it the nickname the Electric City. On November 30, 1886, passengers boarded Scranton's very first electric trolley at the Academy of Music, opposite St. Luke's Church on Wyoming Avenue. They had been attending a lecture at the Academy of Music by renowned explorer Henry M. Stanley. This was the electric trolley's maiden run, and the excited passengers boarded the car from the rear and prepared to ride in elegance. The Pullman cars were the finest ever built, measuring sixteen feet in length, with seating for thirteen people on either side of the aisle. The front platform was enclosed, and the cars were painted a deep maroon color. Incandescent electric lamps, another exciting new innovation, lit the interior. Scranton had streetcars before these electric marvels, but they were horse-drawn along tracks whose beds were often rutted and muddy. The fare for a trip on the horse-drawn trolley was twenty-five cents. The new electric trolleys cost only a nickel.

Scranton's was not the first electric railway in the country, but it was the first one built to run solely on electric power. In those early days of electricity, it was truly a marvel. The Scranton Suburban Railway Company was organized with Mr. Edward B. Sturges as president and Colonel George Sanderson as secretary. Construction of the road began

on July 6, 1886, and was completed in Green Ridge in November. The railway system was equipped with its electrical apparatus by the Van DePoele Electric Manufacturing Company. Mr. C.E. Flynn installed the electrical equipment. The current was generated by a sixty-horsepower generator. The motor was located on the front platform in constant sight of the driver, who handled the crank, turning the current on or off and regulating the speed of the motor. Cars traveled at a rate of between four and fifteen miles per hour. The railway company paid a fee of nine dollars per day to the electric power company, and the cars ran along this route from 7:00 a.m. to midnight.

A trial run was made on November 29, with Mr. Van DePoele himself at the controls and Mr. Flynn in charge of the motor. The test run showed slight defects in the system, which were quickly fixed. The next evening, the evening of its maiden passenger run, the trolley pulled away from the Academy of Music and followed its route from Wyoming Avenue, up Spruce Street and past the new courthouse. It turned onto Adams Avenue, climbed the steepest hill on the route and proceeded on to Green Ridge, then a suburb of Scranton, where the route ended. The next day's issue of the *Scranton Republican* newspaper reported on the passenger trip: "The cars at times yesterday attained a speed of twelve miles an hour, but can be made to go much faster. It looks as though Scranton has solved the rapid transit problem." The company expanded, to the point where it operated 110 miles of track in and around Scranton, and a passenger could hop a car every fifteen minutes. Sadly, the electric trolley system declined. On December 18, 1954, George Miller operated the very last trolley run, taking passengers home to Green Ridge along the very same route taken by the first passenger run.

Theatres

"If you can play Scranton, you can play anywhere" was a well-known saying in the heyday of vaudeville, when performers made their living by traveling the country's cities and entertaining the crowds. The saying

originated because Scranton audiences were said to be a tough lot who had little patience for stale material, were suspicious of anything new and demanded to be entertained for their hard-earned money. The first vaudeville theatre, Washington Hall, opened in 1870. Small and dirty, it was shunned by the "better classes." Theatre life expanded when Klein's Opera House opened in 1871 at 510–512 Lackawanna Avenue and offered vaudeville-style productions. The Academy of Music opened in 1877 at 225 Wyoming Avenue and took the city's theatre life in a whole new direction. Considered one of the finest theatres in the country, the Academy of Music had a world-class stage, dress boxes, an orchestra circle and balcony and gallery seating for 1,500. It featured first-class acting and operatic troupes. But theatre life was not to remain static. Arthur Frothingham ushered in yet another era when, on March 26, 1894, he opened his Frothingham Theatre at 213–215 Wyoming Avenue. An architect who owned valuable coal land, Frothingham designed the building in a Moorish style that reflected the Alhambra Palace in Spain. Its distinct exterior included two onion-shaped domes. Frothingham came up with the idea to auction off boxes, and the first sold for a whopping fifty dollars. His theatre became the setting for the popular new musicals that were showing in New York and other cities. The theatre was also a popular venue for minstrel shows.

In the heyday of Scranton's theatre scene, *the* place to go was Zenke's Restaurant, where you could relax in style, enjoy a sumptuous meal and even catch a glimpse of a star. Located at 213 Penn Avenue, the Bavarian-style building included overhanging roofs, stucco and beam exterior and an elegant tower. Inside, the German atmosphere was warm and congenial, with wood-paneled walls and shelves graced by decorative beer steins. The food matched the surroundings: rabbit and venison in season, homemade sauerkraut and Hungarian goulash, lobster, freshly made salad dressings and mayonnaise and the signature Steak ala Zenke. The large barroom was noted for its fresh oysters and clams, always on display in season.[87]

By the 1930s, Hollywood had ushered in the age of movies, and the Comerford Theatre helped Scranton make that transition. Built on the site of the former Ritz Theatre, it had its history in the Poli Theatre and the likes of comedienne Fanny Brice, dancers Fred and Adele Astaire, Jack Benny and Will Rogers. Mr. S.Z. Poli sold his theatre to the Comerford Chain in 1925. The chain operated the theatre as the Ritz until it decided to rebuild. On September 16, 1937, two lines of patrons formed along

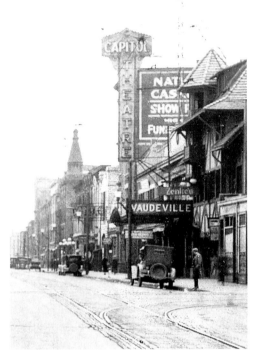

Left: The Bavarian style of Zenke's Restaurant, next to the Capitol Theatre, is easily recognizable in this early twentieth-century photograph. *Courtesy* Scranton Times-Tribune.

Below: Under construction in 1929 is the Masonic Temple and Scottish Rite Cathedral, designed by Raymond Hood, who designed Radio City Music Hall. *Courtesy* Scranton Times-Tribune.

Wyoming Avenue to await the opening of the new Comerford Theatre. Inside they found two grand staircases with ornamental bronze railings leading to the mezzanine, murals decorating the walls, plush carpeting on the floors and mohair seats, spaced so as to allow plenty of leg room. An air conditioning system—an innovation for the time—cooled the premises for summertime comfort. Patrons were assured that its Freon gas was odorless and harmless. The new projection booths held modern Simplex projectors, with sound heads attached, as well as two effect and spot machines. Together, they produced a picture and sound quality found in very few theatres in the state. Lighting effects lent an atmosphere befitting one of the most modern and elegant theatres in the country. The stage was not abandoned in favor of motion pictures. In fact, the new stage was considerably larger than the one that had been in the Ritz, with a proscenium arch measuring forty-four by thirty feet and a stage eighty feet wide and forty feet deep. The balcony was supported by the largest steel girder the city had yet seen, and glazed terra-cotta tiles formed a beautiful façade that would take its place as a Scranton landmark.

Another of the city's well-known theatres, the Strand, hosted an exciting event on August 29, 1936, when hometown girl Jeanne Madden returned for the premiere of her film *Stage Struck*, in which she starred with Joan Blondell and Dick Powell. Two years later, on April 1, 1938, Madden and another Scranton native, opera star Thomas L. Thomas, met Alan Jones at the DL&W station. The MGM star was former soloist of St. Luke's Episcopal Church. Scranton's Emma Matzo starred in *You Came Along*, a film that premiered in the city on August 17, 1945. Her stage name was Lizabeth Scott.[88] Movies and theatre came together in one stellar year—1973—for Scranton native Jason Miller. That year, Miller won a Pulitzer Prize for his play *That Championship Season*. That same year, he won a Tony award for his performance in the play and was nominated for an Oscar for his portrayal of Father Karras in the film *The Exorcist*. Later in his life, Miller returned to his native Scranton, where he died in 2001 at age sixty-one.[89]

Luna Park

A glorious example of the enchanting amusement parks that made this era special, Luna Park opened on May 28, 1906. Frederick Ingersoll, owner of Ingersoll Construction Company in Pittsburgh, had already built Luna Parks in Pittsburgh and Cleveland, and he chose Scranton as the site for another. He bought a twenty-acre site and began construction. Luna Park was advertised heavily while it was under construction, a project that reportedly used 1.5 million feet of lumber. Ingersoll touted his amusement park as "a family resort where women and children, unescorted, will be afforded as much protection as in their own homes." The location was ideal and easy to get to. People could ride the city trolley to Nay Aug Park, walk through the park, cross Roaring Brook and enter at Luna's west entrance. Passengers along the Laurel Line route could board that train and arrive at the park's east entrance.

The day after the park opened, the *Scranton Times* reported the event as follows: "Robed in electric brilliancy and dazzlingly beautiful, Luna Park, the new and magnificent Scranton pleasure resort, glittered last night in all its glory in honor of its opening." Forty thousand incandescent bulbs lit the

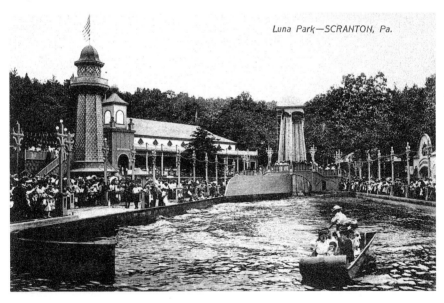

Luna Park—SCRANTON, Pa.

This postcard image shows the Shoot-the-Chute and the lagoon at Luna Park. *Courtesy Lackawanna Historical Society.*

Left: Anna Andrake (the author's great-grandmother) and her younger brother, Andrew Andrake, at Luna Park in June 1907. *Courtesy the author.*

Below: Arthur Frothingham opened Rocky Glen amusement park in 1886. The lake and bathing pavilion are seen here. *Courtesy Lackawanna Historical Society.*

Bathing Pavilion and Slide, Rocky Glen

park at night. Its magnificent buildings included a dance hall, restaurants and a ballroom. Guests could ride the Scenic Railway roller coaster, Shoot-the-Chute or the carousel. The reptile zoo and the circus platform offered exotic entertainments. The Trip to Rockaway simulated a boat excursion, complete with waves that made some riders seasick. The aerial swing and the miniature railroad were favorites, while the bandstand allowed for musical entertainments such as marching bands. Ethnic groups often held special days at Luna Park, as they did at Rocky Glen (see the photograph of Welsh Day at Rocky Glen on page 76). These events drew as many as thirty thousand people. The park held other special events, such as the Charlie Chaplin contest. For that, the Pennsylvania Feature Film Company promised to make a "one-reel film" of the person who won the prize for his imitation of the famous actor. Visitors could dine in the restaurant run by E. & H. Williams of the well-known Scranton firm of J.D. Williams & Bro.

In 1909, Ingersoll overextended himself. He closed and razed the Pittsburgh Luna Park in June 1911. Ingersoll declared bankruptcy, and Scranton's Luna Park fell into other hands. The park had not fallen victim to Ingersoll's money woes; rather, disaster struck. On August 23, 1916, the *Scranton Times* reported:

> *Fire of unknown origin completely destroyed the dance pavilion, roller coaster station and part of the shoot the chutes in Luna Park at 3 o'clock this morning. Although a company of firemen were still pouring water into the smouldering debris today, a force of carpenters commenced removing the cooled embers in preparation for rebuilding the destroyed sections.*

The north side of the park was at Myrtle Street, a residential neighborhood, and the fire's heat forced many residents to flee. Others sprinkled their roofs to prevent the sparks from igniting their homes. Damages to the park were estimated at $15,000. The insurance policy had expired some months before, and so the place was uninsured. Luna Park never recovered from this devastating fire, but during its short life, it made an indelible mark on the memories of Scranton's residents.[90]

NAY AUG PARK, THE EVERHART MUSEUM AND LAKE LINCOLN

Parks were once found only on the estates of the wealthy. The public park did not come into its own until the nineteenth century. Then, every cosmopolitan city had to have one, and Scranton was surely no exception. In 1886, with Ezra Ripple as mayor of Scranton, William Connell, Michael Miller and Lewis Pughe formed a commission to acquire the lands for the city. Part of the land they chose was owned by the Beckett estate of Philadelphia and part by the Lackawanna Iron & Coal Company. Complications surrounding the land titles delayed the purchase until 1893, at which time Ripple was a park commissioner and Connell was mayor. The original purchase devoted 76.67 acres of land to the establishment of the park. The first bridge opened on October 23, 1894, connecting Elmhurst Boulevard with the newly extended Mulberry Street. As a toll bridge, it was open to horse and buggy traffic and offered an important means of connecting the populations on either side of the brook. Early twentieth-century postcards clearly show two bridges: a larger one that was once open to traffic, and a smaller footbridge. The larger bridge was closed to traffic in the 1930s or 1940s.

Scranton's Dr. Isaiah Everhart had an extensive natural history collection that he wished to give to the city, along with a museum to house it. Nay Aug Park offered an ideal location. On May 30, 1908, at a ceremony attended by throngs of people, Mayor Benjamin Dimmick accepted the Everhart Museum on behalf of the City of Scranton. The building cost the doctor $100,000 to build. The collections he donated were valued at $50,000. Everhart, who had made a great deal of money through his coal interests, also gifted to the city an endowment of $101,000 for the purpose of maintaining the building. Dr. Everhart invited the public to the ceremony through a letter to the newspaper. A reserved man, he chose not to speak at the event and instead asked Colonel Watres to represent him. "The event we are now participating in," Colonel Watres said in his speech, "will mark a new era in our city's career." Colonel Watres's words expressed exactly the attitude of this growing city. "This splendid and useful museum," he said, "not only beautifies our park and furnishes our city with an unique institution of great educational value, but it lends a distinct impetus to civic pride, that splendid asset which makes for civic progress."

Dr. Everhart died on May 26, 1911, just three years after the museum was dedicated. Shortly after his death, a bronze statue was unveiled in front

of the museum, the gift of Dr. B.H. Warren, a naturalist from West Chester who had greatly admired Everhart and his work. The park became a regular spot for city dwellers looking to escape the heat and bustle of town and enjoy the beauty of nature. Complete with walking paths, pavilions, a public drinking fountain and the Everhart Museum, its natural setting at the edge of town made it an ideal summer retreat.

About 1906, area residents began calling for a public swimming pool to ease the heat of long summer days. City Engineer Blewitt found that a large slab of rock near the museum would make a natural retaining wall for the east end of a pool. The city submitted plans to area contractors, and Peter Stipp was awarded the contract of $11,500. Raising the money for the project proved challenging, as city council was not prepared to appropriate such a sum. But the residents of this city had an attitude that moved them to pull together, take matters into their own hands and accomplish what they believed needed to be done. Mayor Dimmick had put William Connell in charge of the project, and he set up a committee to take charge of raising funds in the community. The citizens of Scranton opened their new pool—Lake Lincoln—on July 4, 1909. Used for swimming in summer and ice skating in winter, Lake Lincoln remained a popular and much-loved gathering place for decades. By 1914, the City of Scranton had invested upward of $60,000 in the development of Nay Aug Park. In 1918, Colonel Louis A. Watres and his wife extended the park through a donation of an additional forty acres on the Elmhurst Boulevard side of the gorge. Lake Lincoln was closed in the 1960s and replaced by a modern pool complex. The original land deeds that brought the park into the city's possession prohibit use for anything but a public park, thus assuring that this tranquil setting will remain in the public trust in perpetuity.

OTHER FORMS OF RECREATION

The hardworking people of Scranton looked for a variety of ways to enjoy themselves during their leisure hours. The year 1880 ushered in a new craze—the bicycle. By 1881, the bicycle craze hit Scranton, and eager

gentlemen who wished to further their interests in cycling established the Scranton Bicycle Club. It was the first official club to form in the city. Two of the founding members were E.B. Sturges, developer of the electric trolley, and George Sanderson, a real estate developer responsible for first developing Green Ridge. Early bicycles had metal wheels, the front wheel considerably larger than the back wheel. In America, this type of bike was known as the "ordinary." Cycling was touted as a healthful, invigorating sport. The rider was free to travel on his own time schedule and could venture just about anywhere he could walk. But the cost was prohibitive. In 1892, a Victor cost $130, a sum that suggests one reason why the original members of Scranton's bicycle club were men of means. Still, the craze spread quickly.

Golf was introduced to Lackawanna County on the eighteen-hole golf course of the Country Club of Scranton. The oldest among the area's country clubs, it was established in Green Ridge, now a section of Scranton but in 1896 a wooded, relatively undeveloped suburb. Organized

The Seembecee Club won the pennant in the Anthracite Basketball League championship in 1930, the year this picture was taken. *Courtesy* Scranton Times-Tribune.

The 1939 Eastern League champion Scranton Red Sox. *Courtesy* Scranton Times-Tribune.

on October 5 of that year, the country club had a clubhouse and grounds at the end of North Washington Avenue. Several American and British cup holders played on this course. The club also did much to popularize tennis among area residents. Four tennis courts, an indoor squash court and a bowling alley completed the complex. But the by-laws of the club reveal the strict attitudes and practices of the time. Games of any kind

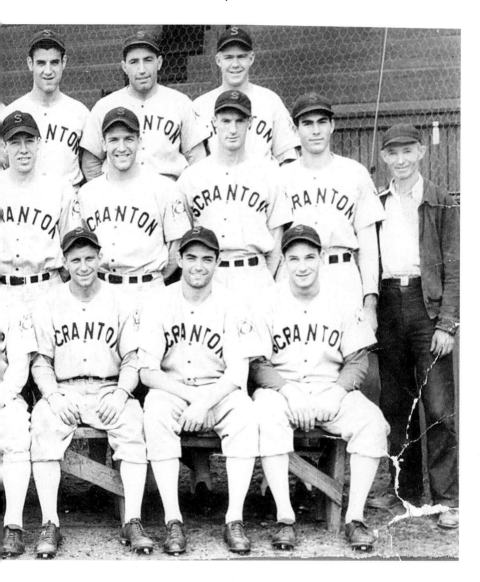

were forbidden on Sundays, starting at closing time on Saturday night and continuing until sunrise on Monday morning, with one exception. The links were available to senior members of the club after 1:00 p.m. on Sunday, but the use of caddies was prohibited, presumably because caddying, like all work, was forbidden on the Sabbath. The by-laws gave the directors power to ban any games or sports that might be considered

"prejudicial to the good order and interest of the club." No games of hazard were allowed. Gambling was prohibited, and no "malt, or vinous or spirituous liquors" were served.

Baseball, the national pastime, provided a source of amusement for audience and participants alike. Both amateur and semiprofessional leagues abounded. The Scranton Lace Company's team played in the Industrial League. The Sauquoit Mill had a women's team, and the Scranton police had a team. Scranton's South Side had its Sterling Diamond team, and the Pennsylvania Coal Company had a team, too. A newspaper story that appeared on July 5, 1887, gives insight into the popularity of this sport in Scranton's early history. The report says that business throughout the city was suspended that afternoon. Why? A baseball game between Wilkes-Barre and Scranton. Five thousand people attended, and Scranton won.[91]

The Scranton Baseball Club was the area's first professional baseball team. Begun as an amateur club in 1865, by 1875 the team realized that it needed to follow the lead of its opponents and invest in professional players if it were to remain competitive. An opposing team, the Philadelphia Athletics, would soon become one of the first major league teams in the country.

From this point on, the Lackawanna Valley would always have ties to the Major Leagues. Ed Murphy gained recognition in an interesting way. "Honest Eddie" Murphy was born in Hancock, New York, but lived in the Scranton area for much of his life. He began his major league career with the Philadelphia Athletics in 1912. In 1915, he was traded to the Chicago White Sox. Murphy earned his nickname during the infamous 1919 World Series scandal, when eight White Sox team members threw the series against the Cincinnati Reds. The scandal made front-page news across the country and earned the team the nickname Black Sox. Murphy's nickname came from the fact that he had not been involved in the incident. The eight players who were involved were suspended from baseball. Murphy spent the last few years of his career with the Pittsburgh Pirates.

Of course, local fans kept their eye on their favorite major league teams, and the World Series drew keen interest. In the days before radio, city newspapers positioned a man with a megaphone so that he could receive plays coming over the wire and announce them to crowds who gathered for the purpose. The *Scranton Times* used to post bulletins in its display windows to provide play-by-play accounts of baseball games. The World Series of 1913 brought an innovation that drew crowds to "watch" the games. The Playograph was an electric scoreboard used by newspapers across the country. The *Scranton Times* was the only newspaper in the city to have one. Set up on the Spruce

Street side of the *Times* building, it depicted a baseball diamond. Plays were sent via telegraph from the site of the game and immediately transferred to the Playograph. An ingenious system of colored lights indicated men on base, each position on the field and whether the batter was safe or out. There were lights to illustrate when a ball was hit foul or safe, where it was hit, who caught it or where it fell in for a hit. Virtually any play that could be made on the field could be shown on the Playograph, even long fouls that looked as though they might drop in fair for a hit. The Playograph offered fans a way to watch the games unfold almost as if they were at the ballpark. Huge crowds gathered to enjoy the World Series, and at times, excitement reached a feverish pitch.

DOWNTOWN COMFORT STATION

By the turn of the century, Scranton had grown into a cosmopolitan city with a lively downtown. Tall buildings housed thriving businesses, elegant shops lined the busy streets and the Lackawanna County Courthouse stood proudly at the center. Its square, designed as a park, offered a cool respite for shoppers and workers. At night, the theatres and lecture halls were full, and the square was also a popular venue for concerts. Public restrooms were a necessity in this bustling city. On December 14, 1915, a thoroughly modern comfort station opened beneath Courthouse Square. This masterpiece of engineering was designed by Frederick A. Fletcher, an architect with the Duckworth firm in Scranton, the same firm that designed the Hotel Jermyn. Fletcher had supervised the building of a similar station in Washington, D.C., several years before. He studied public facilities in Washington, D.C., Boston, Philadelphia and Wilkes-Barre and then borrowed the best features of each to create what was said to be the finest comfort station in the country.

Carlucci and Company, another well-known Scranton business, was the general contractor on the project, with the firm of Palumbo and Kroft doing the concrete work. The station had two entrances: the gentlemen's entrance on the Washington Avenue side of the square and the ladies' entrance on the Spruce Street corner. The station itself measured eighteen by sixty-

four feet overall. The floor of the structure was twelve feet under the street level. A solid eighteen-inch concrete wall assured that the building was protected from dampness. Specially constructed ducts formed a circulation system that provided a complete change of air every three minutes. In the winter, fresh air passed over heat coils before it circulated throughout the interior, warming the air to a comfortable temperature. In summer, the air passed over cooling coils. Every detail of the interior was designed for optimum sanitation. Georgia marble, white enamel, metal and brass allowed for efficient cleaning. The five interior rooms were designed with rounded corners, permitting an attendant to clean without dirt collecting in sharp corners. Each of the rooms contained air ducts that allowed circulation throughout the structure. The basins also contained large ducts for air circulation, a special innovation of the architect. Air from inside the structure was forced out through a vent located near the Soldiers and Sailors Monument. Fresh air was pumped in through radiators located just above the entrance. Aside from the entrance and the air vent, the station was not noticeable from the surface. But anyone who worked, shopped or played downtown knew that it was there. The comfort station provided just one more bit of luxury and innovation in Scranton.[92]

Laurel Line

Efficient transportation was in constant demand in this bustling city. Early in 1900, William Connell and his associate, George A. Lee of Philadelphia, began to plan a high-grade electric railroad. Scranton's extensive trolley system provided efficient and affordable transportation within the city and to nearby towns, but the system that Connell and Lee proposed would run between Carbondale and Wilkes-Barre, passing through Scranton. The partners obtained general railroad charters from the State of Pennsylvania for the following companies: Scranton and Northeastern Railroad Company, Central Valley Railroad Company and Northern Lackawanna Railroad Company. Construction began early in 1901. On June 20, 1913, these companies were merged into one under the name Lackawanna and

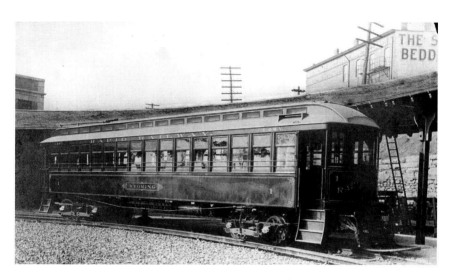

A car from the Laurel Line, which took passengers to Wilkes-Barre and to the boroughs north of Scranton. *Courtesy Lackawanna Historical Society.*

Wyoming Valley Railroad. The name Laurel Line was chosen as a pleasant-sounding name based on the fact that the line ran through mountainous areas covered in mountain laurel. Passenger service began on May 25, 1903, on the line between Scranton and Pittston. Freight service began in August 1903. But the plan was yet to be complete. On September 15, the operation was extended to Plains, and on December 16 it was extended to Wilkes-Barre. The Dunmore branch was completed and placed in operation on June 20, 1904. The company made its own power at its Scranton power station, which had a capacity of five thousand kilowatts. It also supplied power to several businesses in the city. By 1914, 258 passenger trains arrived at and departed from its Scranton terminal every twenty-four hours,[93] a figure that attests to the wisdom of Connell and Lee in this business venture.

CONCLUSION

A City Lives Its Legacy

The late twentieth century brought tremendous change to the nation's industrial cities. The mid-century ushered in a period of modernization, and the nineteenth- and early twentieth-century structures that had defined these cities gave way to modern office buildings, strip malls and shopping centers. The demise of Scranton's largest industries—coal mining, railroading and mills—had left the city financially strapped, but good did come from hardship. Many of Scranton's oldest buildings survived this era intact. For that reason, the footprint of the city has changed little since the 1870s. Joel Amsden laid out the city in the 1850s with Lackawanna Avenue as its main shopping thoroughfare. Gone are the butchers and bakers, the hardware dealers and other shops that once graced this street, but much of the architecture from the 1880s and 1890s has survived. Early in the twenty-first century, with Christopher Doherty as Scranton's mayor, the city began a restoration project of the 500 block of this historic street. Lackawanna Avenue became a mix of modern buildings—including the Mall at Steamtown, built in the 1990s—and gracious old architecture that recalls Scranton's past.

Many of the nineteenth- and early twentieth-century landmarks still define the city. The Albright Memorial Library, as the main branch of the Lackawanna County Library System, carried its tradition of serving the public into the twenty-first century, adding items such as CDs, DVDs and computers to its offerings. The old theatres have disappeared, but the Masonic Temple kept reinventing itself by expanding its public offerings.

The Broadway Theatre League formed in 1959 to bring traveling Broadway shows to the city. It took up its home in the Masonic Temple and celebrated its fiftieth anniversary in 2009. In January 1970, the newly formed Northeastern Pennsylvania Philharmonic announced itself. Formed from philharmonic groups from Scranton and Wilkes-Barre, it presented its debut performance to Scranton on October 22, 1972, at the Masonic Temple. The program included, among others, Beethoven's Fifth Symphony, and the philharmonic remained in its home at the Cultural Center at Masonic Temple into the twenty-first century.[94]

Other landmarks took on new functions in the latter decades of the twentieth century. The city's two largest department stores—the Globe Store and Scranton Dry Goods—were renovated to accommodate offices. The Globe became the home of Diversified Information Technologies, specializing in information storage, and the Dry became home to local Internal Revenue Service (IRS) offices and others. Alas, the Hotel Casey did not survive the twentieth century, but the Hotel Jermyn was renovated as a housing facility. The former Delaware, Lackawanna & Western Railroad's passenger station became a hotel in the 1980s, and in 1995, it became the Radisson at Lackawanna Station Hotel. The elegant old waiting lounge, with its Sienna marble, vaulted glass ceiling and scenic panels, became an elegant setting for Carmen's Restaurant. The Lackawanna County Courthouse underwent some much-needed renovations in the early twenty-first century, standing not only as the seat of county government but also as a proud monument to the sixty-seventh and last county formed in Pennsylvania.

Scranton is no longer the major industrial center that it once was, but its institutes of higher education have been a major force in Scranton's renewal. St. Thomas College, founded in 1888, became the University of Scranton in 1938 when the Jesuits took it over. Beginning in the later 1980s, the school expanded, erecting, on average, one new building per year into the twenty-first century. In 2009, it welcomed the largest freshman class in its history, with over one thousand students.[95] Marywood University, founded in 1915 as Marywood College by the Sisters, Servants of the Immaculate Heart of Mary, welcomed the first students to its new School of Architecture in 2009, with Gregory K. Hunt, FAIA, as its founding dean.[96] Lackawanna College, founded in 1894 as the Scranton Business College, continued to grow, moving into and restoring the former Scranton Central High School building on Vine Street at North Washington Avenue and several other historic buildings, including the old Young Men's Hebrew Association.[97] In

2009, the college became a temporary home for the city's newest educational endeavor, the Commonwealth Medical College—the first new medical school to be formed in Pennsylvania in four decades. With President Robert D'Alessandri, MD, TCMC welcomed its first class in August 2009 and, in the meantime, began construction of its own facilities. The school started in response to the state's shortage of doctors, and a significant part of its mission is to train new doctors who will remain in northeastern Pennsylvania to practice medicine.[98]

By the late twentieth century, tourism had taken over as Pennsylvania's second-largest industry, and Scranton found itself a destination for historical tourism. The Lackawanna Institute of History and Science was founded in 1886, and in 1965, Lackawanna County designated the Lackawanna Historical Society (as it is now called) as the official county historical society. The LHS maintains an extensive collection of books, documents, photographs and other artifacts that help it to both preserve and interpret the history of Lackawanna County through its downtown walking tours and many other public programs. The organization remained in its headquarters, the George Catlin Memorial House—one of the last remaining estate homes in a neighborhood that once included the homes of Joseph H. Scranton and James Archbald.[99] In 1986, Steamtown National Historic Site was created to preserve America's steam railroading history. Under the administration of the National Park Service, its museum, working roundhouse and excursion trains are located at the site of the former rail yard and shops of the Delaware, Lackawanna & Western Railroad.[100] The Anthracite Heritage Museum preserves and interprets the region's coal mining history, while the county-operated Coal Mine Tour offers the experience of traveling three hundred feet below ground into a once-working coal mine. Scranton's Historic Iron Furnaces preserve the one remaining furnace from among the five that were once in operation at the Lackawanna Iron & Coal Company. The Pennsylvania Historical and Museum Commission established the Anthracite Heritage Museum and took ownership of the Historic Iron Furnaces. To preserve and interpret the city's electric trolley heritage, the Electric City Trolley Museum Association[101] opened its museum on the grounds of Steamtown National Historic Site and began excursions aboard an electric trolley that follows the old Laurel Line tracks. Early in the twenty-first century, the museum began excursions to the Lackawanna County Stadium, home of minor league baseball. The Scranton Wilkes-Barre Yankees won the Governor's Cup in 2008.

The industrial development of the Lackawanna Valley made it a unique place. In 1991, that legacy was honored when the Lackawanna Heritage Valley Authority was established and named Pennsylvania's first state heritage park. The following year, the United States Congress designated it a national heritage area. LHVA works with like-minded organizations to promote the area's heritage. Its Greenway & Trail project helped transform miles of the Lackawanna River's shores into walking trails and beautiful public spaces.[102]

The people of Scranton have inherited a rich heritage and a proud legacy. As the city moved into the twenty-first century, it carried with it the customs and traditions of its ancestors and the indomitable spirit that made Scranton the Electric City and the Anthracite Capital of the World. Within a cityscape that recalls past glory, the people of Scranton continue to celebrate their heritage and find new ways to meet the demands of a changing world.

NOTES

CHAPTER ONE

1. Horace Hollister, MD, *History of the Lackawanna Valley with Illustrations, Fifth Edition, Revised and Enlarged* (Philadelphia: J.B. Lippincott, Company, 1885), 29–32. Dr. Hollister published the first edition of this book in 1857. His work is by far the most complete we have on the early history of the Lackawanna Valley. His books are, however, rather scattered in their presentation of that history. Furthermore, some details that appear in the 1857 edition never made it into the fifth edition, published in 1885. I rely heavily on the fifth edition but occasionally need to refer to the 1857 edition. Because his presentation is scattered, and because copies of his books are not readily accessible for general reading, where possible I have pointed the reader to other, modern sources that recount or summarize the history.

2. In the language of the native peoples, the prefix *lee* signifies a fork or point of intersection, while *hanna* designates a stream. The Lackawanna River is met, in Scranton, by Roaring Brook, and down farther, it flows into the Susquehanna River, which also uses the *hanna* root. Hollister, *History of the Lackawanna Valley*, fifth ed., 41.

3. Hollister, *History of the Lackawanna Valley*, fifth ed., 29–32.

4. Nicholas E. Petula, *Pioneer Neighborhood: A History of Park Place and Bull's Head, Scranton, Pennsylvania* (Scranton, PA: self-published, 1996), 5.

5. See Mark G. Dziak's *The Battle of Wyoming for Life and Liberty* (Pittston, PA: self-published, 2008).

6. As colonies of the British empire, they used the British currency system of pounds, shillings and pence.

7. Hollister, *History of the Lackawanna Valley*, fifth ed., 106–129, 186–87, 334.

8. For a concise version of this history, see Petula, *Pioneer Neighborhood*, 4–8.

9. Hollister, *History of the Lackawanna Valley*, fifth ed., 127–40.

10. For an excellent, detailed account of the history of these events, see Dziak's *Battle of Wyoming*.

11. Petula, *Pioneer Neighborhood*, 6–7.

12. Hollister, *History of the Lackawanna Valley*, fifth ed., 128–29.

13. For more information, see Petula, *Pioneer Neighborhood*, 7–8.

14. Edward Merrifield, *The Territory of Scranton Immediately Prior to the Lackawanna Iron and Coal Co. Purchase: Historical Notes No. 4* (Scranton, PA: Lackawanna Historical Society, n.d.), 4.

15. Hollister, *History of the Lackawanna Valley*, fifth ed., 61, 145–49, 192, 201–3, 216, 312.

16. Merrifield, *Territory of Scranton*, 4.

17. Hollister, *History of the Lackawanna Valley*, fifth ed., 97, 150–51, 201–14, 277.

18. Ibid., 101–3, 199–222, 277.

CHAPTER TWO

19. Edward Merrifield, *The Founders of Scranton: Historical Series No. 5* (Scranton, PA: Lackawanna Institute of History and Science, 1925), 3.

20. Daniel K. Perry's *"A Fine Substantial Piece of Masonry"* offers an excellent, concise account of these early furnaces. See pages 2–5.

21. The company reorganized, changed partners and changed names several times. In 1846, J.C. Platt took over Sanford Grant's role as manager of the stores, and the company reorganized as Scrantons & Platt. In 1853, the company reorganized again as the Lackawanna Iron & Coal Company, the name which is most commonly used today to refer to this company.

22. Manness was to supervise the building of just about every structure associated with the Lackawanna Iron Works and, later, the first shops belonging to the Delaware, Lackawanna & Western Railroad. See Perry, *"A Fine Substantial Piece of Masonry,"* 9.

23. Interview with the *Scranton Republican*, quoted in Perry, *"A Fine Substantial Piece of Masonry,"* 14.

24. This section contains information that is found in both Hollister's *History of the Lackawanna Valley* and Colonel Frederick L. Hitchcock, *History of Scranton and Its People*, vol. 1 (New York: Lewis Historical Publishing Company, 1914). For a concise and thorough history of the development of the iron furnaces, see Perry, *"A Fine Substantial Piece of Masonry."*

25. For the most concise account of these dealings, see Perry, *"A Fine Substantial Piece of Masonry,"* 19–20.

26. William W. Scranton, son of Joseph H. Scranton, acted as general manager during this period. In 1881, he resigned and founded his own company, Scranton Steel Company. In 1884, Lackawanna Iron & Coal Company was renamed Lackawanna Iron & Steel. In 1891, Scranton Steel and Lackawanna Iron & Steel merged under the name of the former. The Scranton Steel Company's property became known as the South Works.

27. Hitchcock devotes the third and fourth chapters of his book to a thorough discussion of the development of this railroad. I have gleaned information from those chapters for this section on the Leggett's Gap/Lackawanna Railroad.

28. Hollister, *History of the Lackawanna Valley*, fifth ed., 339.

29. Hollister details the development of coal in Carbondale in his *History of the Lackawanna Valley*, fifth ed., 343–67; for an extensive discussion of coal development in the region, see Hitchcock, *History of Scranton*, chapter 5.

30. Hitchcock, *History of Scranton*, 61–68, 277–79.

31. Hollister, *History of the Lackawanna Valley*, fifth ed., 491; Hitchcock, *History of Scranton*, 107, 112, 660–63.

32. For more about Scranton's Civil War history, see the discussion of the Watres Armory in the third chapter.

33. Information about these men and all Medal of Honor recipients can be found at the Medal of Honor website, http://www.history.army.mil/moh.html.

34. For a thorough discussion of the Dickson family and the Dickson Manufacturing Company, see Hollister, *History of the Lackawanna Valley*, fifth ed., 265–66, 480–84; and Hitchcock, *History of Scranton*, 89–91, 492–93. I have taken information from these pages.

35. Scranton Board of Trade, *Scranton: A Progressive City* [a special issue of the *Scranton Board of Trade Journal*] 2, no. 12 (October 1915).

36. Lackawanna County news excerpts from the *Scranton Times*.

37. Gene Coleman, "Ice Museum Hottest Idea in Town," *Scranton Times*, February 12, 1967.

38. Hitchcock, *History of Scranton*, 354–55.

39. "Mary Brooks Picken Sumner," undated obituary found in files at Lackawanna Historical Society, Scranton, Pennsylvania.

CHAPTER THREE

40. The details of the neighborhood can be found on Joel Amsden's map of Scranton, dated 1857, property of the Lackawanna Historical Society, and located in the Scranton City Directory of that year.

41. Hitchcock, *History of Scranton*, 181–85, 445–48.

42. Ibid., 361–62.

43. Cheryl A. Kashuba, Darlene Miller-Lanning and Alan Sweeny, *Scranton* (Charleston, SC: Arcadia, 2005), 57.

44. Daniel L. Cusick, "Telephone Celebrates Its 100th Anniversary," *Scranton Times*, March 7, 1976; *Scranton Board of Trade Journal*, "Scranton Live Wire," September 1915.

45. Hitchcock, *History of Scranton*, 149.

46. Ibid., 96, 329, 363–74; Kashuba, Miller-Lanning and Sweeny, *Scranton*, 58–59.

47. Hitchcock, *History of Scranton*, 372.

48. Ibid., 523–24.

49. Kashuba, Miller-Lanning and Sweeny, *Scranton*, 63.

50. Pennsylvania National Guard, www.milvet.state.pa.us/DMVA/166.htm.

51. Kashuba, Miller-Lanning and Sweeny, *Scranton*, 38. The station closed in 1970 and lay vacant until 1983, when it opened as a hotel. In 1995, the hotel became part of the Radisson chain.

52. Petula, *Brewed in Scranton: A History of the Brewing Industry in Scranton, Pa.* (Scranton, PA: self-published, 1988), 52–53.

53. Hitchcock, *History of Scranton*, 153.

54. Hollister, 1885 ed., 250.

55. *Portrait and Biographical Record of Lackawanna County Pennsylvania*, "Conrad Schroeder" (New York and Chicago: Chapman Publishing, 1897), 193–94.

CHAPTER FOUR

56. Victor Alfieri Society, http://victoralfierisociety.com/Home.html.

57. Petula, *Brewed in Scranton*, 29–34. This book details the history of the extensive brewing industry in Scranton.

58. Hitchcock, *History of Scranton*, 423, 657–58.

59. *Portrait and Biographical Record of Lackawanna County Pennsylvania*, "Frank Carlucci" (New York and Chicago: Chapman Publishing, 1897), 669.

60. Hitchcock, *History of Scranton*, 467.

61. German singers were part of the Choral Union that won against Salt Lake City, too. They were members of the Scranton Liederkranz and Junger Maennerchor.

62. Hitchcock, *History of Scranton*, 467–69.

63. Matthew S. Magda, *The Poles in Pennsylvania. The People of Pennsylvania, Pamphlet No. 3* (Harrisburg: Pennsylvania Historical and Museum Commission, 1986); Polish National Catholic Church, www.pncc.org/who.htm.

64. Emerson Moss, *African-Americans in the Wyoming Valley* (Wilkes-Barre, PA: Wyoming Historical and Geological Society, 1992), 64. Additional information comes from research conducted by the Center for Anti-Slavery Studies, based in Montrose, Pennsylvania.

65. Thomas Costello, *Patrick W. Costello: Engrosser, Illuminator, Illustrator, Pen & Ink Portrait Artist*, unpublished manuscript, used with permission of the author.

Chapter Five

66. Hitchcock, *History of Scranton*, 448–49, 457–58, 517, 553–55.

67. Ibid., 459–63.

68. Ibid., 351–53.

69. Ibid., 319–20.

70. Ibid., 463–65.

Chapter Six

71. For one man's perspective on Scranton's 1877 labor riot, see Samuel C. Logan, *A City's Danger and Its Defense* (Philadelphia: Jas. B. Rogers Printing Company, 1887). Logan was pastor of Scranton's Presbyterian church at the time of the riots.

72. Proceedings of Monday, December 15, 1902, reprinted in the *Scranton Tribune* on December 16.

73. Miners were paid according to how much coal they mined, and one of their complaints was that weighing practices cheated them out of wages.

74. Numerous sources detail labor conditions, the United Mine Workers Union and these hearings. One local source is Jack McDonough, *The Fire Down Below: The Great Anthracite Strike of 1902 and the People Who Made the Decisions* (Scranton, PA: Avocado Productions, 2002).

75. The year the strike hearings concluded, 1903, John Mitchell published a book called *Organized Labor: Its Problems, Purposes, and Ideals and the Present and Future of American Wage Earners* (Philadelphia: American Book and Bible House, 1903).

76. Hitchcock, *History of Scranton*, 32.

77. Ibid., 344–45.

78. *Golden Anniversary Edition: Scranton Board of Trade Journal*, November 1917.

79. *New York Times*, "Train Sends First Wireless to Times: Message of Greeting from a Lackawanna Special Going 64 Miles an Hour," January 23, 1914.

80. Tom Casey, "Wreckers Moving in on First Radio Station," *Scranton Tribune*, July 13, 1962.

81. "Dime Store Dynasty: The Scranton Button Company Story." www.economicexpert.com/a/Emerson:Records.htm.

82. Gene Coleman, "Ice Museum Hottest Idea in Town," *Scranton Times*, February 12, 1967.

83. Petula's *Brewed in Scranton* contains an excellent account of the beer industry during these years.

84. Hitchcock, *History of Scranton*, 319–20.

85. Medal of Honor citations, http://www.history.army.mil/moh.html.

86. Scranton Chamber of Commerce, *Scranton: Murray Plant Dedication* (Scranton, PA: Scranton Chamber of Commerce, April 1944).

CHAPTER SEVEN

87. Nancy McDonald, *If You Can Play Scranton* (Scranton, PA: self-published, 1981), 81; *Scranton Times*, "Albert Zenke Marks His 80th Birthday," February 14, 1957.

88. McDonald, *If You Can Play Scranton*, 69–70.

89. Robin Pogrebin, "Jason Miller, Playwright and Actor, Dies at 62," *New York Times*. http://www.nytimes.com/2001/05/15/arts/jason-miller-playwright-and-actor-dies-at-62.html.

90. Jack Hiddlestone, *A Return to Scranton Luna Park* (Scranton, PA: self-published, 2004). Surprisingly, Luna Park is left out of the old books that recount Scranton's history. In this book, as well as his first book on the subject, Mr. Hiddlestone has gleaned information from numerous newspaper articles, as well as from an extensive collection of memorabilia that includes postcards, brochures, advertisements, photographs and maps. His work is an invaluable source for anyone interested in this wonderful park.

91. Hitchcock, *History of Scranton*, 517.

92. *Scranton Times*, "Beauty and Comfort Combined in City's First and Only Comfort Station," December 13, 1915.

93. Hitchcock, *History of Scranton*, 115–16.

CONCLUSION

94. Northeastern Pennsylvania Philharmonic, www.nepaphil.org/index.php.

95. University of Scranton, www.scranton.edu.

96. Marywood University, www.marywood.edu.

97. Lackawanna College, www.lackawanna.edu.

98. The Commonwealth Medical College, www.thecommonwealthmedical.com.

99. Lackawanna Historical Society, www.lackawannahistory.org.

100. Steamtown National Historic Site, www.nps.gov/stea/faqs.htm.

101. The Electric City Trolley Museum Association, www.ectma.org.

102. Lackawanna Heritage Valley Authority, www.lhva.org.

BIBLIOGRAPHY

Casey, Tom. "Wreckers Moving in on First Radio Station." *Scranton Tribune*, July 13, 1962.

Coleman, Gene. "Ice Museum Hottest Idea in Town." *Scranton Times*, February 12, 1967.

The Commonwealth Medical College. www.thecommonwealthmedical.com.

Costello, Thomas. *Patrick W. Costello: Engrosser, Illuminator, Illustrator, Pen & Ink Portrait Artist*. Unpublished manuscript, used with permission of the author.

Cusick, Daniel L. "Telephone Celebrates Its 100th Anniversary." *Scranton Times*, March 7, 1976.

The Diocese of Scranton. www.dioceseofscranton.org/index.asp.

Dziak, Mark G. *The Battle of Wyoming for Liberty and Life: The Whole Story of the 1778 Battle and Massacre in Wyoming Valley, Pennsylvania*. Pittson, PA: self-published, 2008.

The Electric City Trolley Museum Association. www.ectma.org.

Emerson Records Company. "Dime Store Dynasty: The Scranton Button Company Story." www.economicexpert.com/a/Emerson:Records.htm.

Golden Anniversary Edition: Scranton Board of Trade Journal, November 1917. Located at the Lackawanna Historical Society, Scranton, Pennsylvania.

Hiddlestone, Jack. *A Return to Scranton Luna Park*. Scranton, PA: self-published, 2004.

Hitchcock, Frederick L., Colonel. *History of Scranton and Its People*. Vol. 1. New York: Lewis Historical Publishing Company, 1914.

Hollister, H., MD. *History of the Lackawanna Valley*. New York: W.H. Tinson, Printer & Stereotyper, 1857.

———. *History of the Lackawanna Valley with Illustrations, Fifth Edition, Revised and Enlarged*. Philadelphia: J.B. Lippincott, Company, 1885.

Kashuba, Cheryl A., Darlene Miller-Lanning and Alan Sweeny. *Scranton*. Charleston, SC: Arcadia, 2005.

Lackawanna College. www.lackawanna.edu.

Lackawanna County news excerpts, *Scranton Times*. Archived at www.rootsweb.com.

Lackawanna Heritage Valley Authority. www.lhva.org.

Lackawanna Historical Society. www.lackawannahistory.org.

Magda, Matthew S. *The Poles in Pennsylvania. The People of Pennsylvania*. Pamphlet no. 3. Harrisburg: Pennsylvania Historical and Museum Commission, 1986.

————. *The Welsh in Pennsylvania. The People of Pennsylvania*. Pamphlet no. 1. Harrisburg: Pennsylvania Historical and Museum Commission, 1998.

"Mary Brooks Picken Sumner." Undated obituary found in files at Lackawanna Historical Society, Scranton, Pennsylvania.

Marywood University. www.marywood.edu.

McDonald, Nancy. *If You Can Play Scranton*. Scranton, PA: self-published, 1981.

McDonough, Jack. *The Fire Down Below: The Great Anthracite Strike of 1902 and the People Who Made the Decisions*. Scranton, PA: Avocado Productions, 2002.

Medal of Honor Citations. www.history.army.mil/moh.html.

Merrifield, Edward. *The Founders of Scranton: Historical Series No. 5*. Scranton, PA: Lackawanna Institute of History and Science, 1925.

————. *The Territory of Scranton Immediately Prior to the Lackawanna Iron and Coal Co. Purchase: Historical Notes No. 4*. Scranton, PA: Lackawanna Historical Society, n.d.

Moss, Emerson. *African-Americans in the Wyoming Valley*. Wilkes-Barre, PA: Wyoming Historical and Geological Society, 1992.

National Baseball Hall of Fame and Museum. www.baseballhalloffame.org/index. jsp.

New York Times. "TRAIN SENDS FIRST WIRELESS TO TIMES: Message of Greeting from a Lackawanna Special Going 64 Miles an Hour." January 23, 1914. http://query. nytimes.com/gst/abstract.html?res=950CE1D81F3BE633A25750C2A9679C9 46596D6CF.

Northeastern Pennsylvania Philharmonic. www.nepaphil.org/index.php.

Pennsylvania National Guard. Commonwealth of Pennsylvania, Department of Military and Veteran Affairs. www.milvet.state.pa.us/DMVA/166.htm.

Perry, Daniel K. *"A Fine Substantial Piece of Masonry": Scranton's Historic Furnaces*. Harrisburg: Pennsylvania Historical and Museum Commission, 1994.

Petula, Nicholas E. *Brewed in Scranton: A History of the Brewing Industry in Scranton, Pa.* Scranton, PA: self-published, 1988.

————. *A History of Scranton Professional Baseball 1865–1953*. Scranton, PA: self-published, 1989.

————. *Pioneer Neighborhood: A History of Park Place and Bull's Head, Scranton, Pennsylvania*. Scranton, PA: self-published, 1996.

Platt, J.C. *Reminiscences of the Early History of "Dark Hollow," "Slocum Hollow," "Harrison," "Lackawanna Iron Works," "Scrantonia," and "Scranton, Pa."* Historical Series no. 2. Scranton, PA: Lackawanna Institute of History and Science, 1886.

Pogrebin, Robin. "Jason Miller, Playwright and Actor, Dies at 62." *New York Times.* www.nytimes.com/2001/05/15/arts/jason-miller-playwright-and-actor-dies-at-62.html.

Polish National Catholic Church. http://www.pncc.org/who.htm.

Portrait and Biographical Record of Lackawanna County Pennsylvania. "Conrad Schroeder." New York and Chicago: Chapman Publishing, 1897.

———. "Frank Carlucci." New York and Chicago: Chapman Publishing, 1897.

Scranton Board of Trade. *Scranton: A Progressive City* [a special issue of the *Scranton Board of Trade Journal*] 2, no. 12 (October 1915).

Scranton Board of Trade Journal. "Scranton Live Wire." September 1915.

Scranton Chamber of Commerce. *Scranton: Murray Plant Dedication.* Scranton, PA: Scranton Chamber of Commerce, 1944.

Scranton Republican. "Observance of Memorable Museum Dedication." Sunday, May 31, 1908.

Scranton Times. "Albert Zenke Marks His 80th Birthday." February 14, 1957.

———. "Beauty and Comfort Combined in City's First and Only Comfort Station." December 13, 1915.

Steamtown National Historic Site. www.nps.gov/stea/faqs.htm.

Throop, B.H., MD. *Dr. B.H. Throop's Historical Notes: Special Publication No. 1.* Scranton, PA: Lackawanna Institute of History and Science, reprinted 1887.

University of Scranton. www.scranton.edu.

Victor Alfieri Society. http://victoralfierisociety.com/Home.html.

Wilcox, William Alonzo. *Early Land Titles of Northeastern Pennsylvania.* Scranton, PA: Lackawanna Historical Society, 1925.

INDEX

ABOUT THE AUTHOR

Cheryl A. Kashuba is a free-lance writer specializing in the history of Scranton. Co-author of two photo histories—*Scranton* (2005) and *The Women of Scranton* (2007)—she has written and produced several living history productions, including the play *Witness to Suffering: The Birth of First Aid in America*. Her local history column has appeared each week in the *Sunday Times* since October 2006. Ms. Kashuba lives in Scranton.